DOODLE DOGS AND SKETCHY CATS

FUN AND EASY DOODLING FOR EVERYONE

BOUTIQUE-SHA

a content + ecommerce company

Doodle Dogs & Sketchy Cats

First Published in the United States of America in 2016 by North Light Books, an imprint of F+W Media, Inc., 10151 Carver Road, Suite 200, Blue Ash, Ohio 45242. (800) 289-0963. First Edition.

a content + ecommerce company

www.fwmedia.com

20 19 18 17 16 5 4 3 2 1

Original Japanese edition published in Japanese language by Boutique-Sha, Tokyo, Japan.

INU NO BALLPEN (no. 1232)

NEKO NO BALLPEN (no. 1233)

Illustrators for **Doodle Dogs**: Fumika Hayashi, Ayumi Takamura, Harumi Matsui

Illustrators for **Sketchy Cats**: Erina Kusaka, Noriko Koshitaka, BOUS original work (yuki), MIWA★, Rieko Wakayama

English language rights, translation & production by World Book Media, LLC
Email: info@worldbookmedia.com

DISTRIBUTED IN CANADA BY FRASER DIRECT
100 Armstrong Avenue
Georgetown, ON, Canada L7G 5S4
Tel: (905) 877-4411

DISTRIBUTED IN THE U.K. AND EUROPE BY
F&W MEDIA INTERNATIONAL
Brunel House, Newton Abbot, Devon, TQ12 4PU, England
Tel: (+44) 1626 323200, Fax: (+44) 1626 323319
Email: enquiries@fwmedia.com

DISTRIBUTED IN AUSTRALIA BY CAPRICORN LINK
P.O. Box 704, S. Windsor NSW, 2756 Australia
Tel: (02) 4560 1600, Fax: (02) 4577 5288
E-mail: books@capricornlink.com.au

ISBN-13: 9781440346965

Manufactured in China.

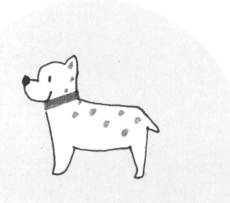

CONTENTS

DRAWING TOOLS: BALLPOINT PENS

We recommend drawing with ballpoint pens. All of the drawings in this book were created using Zebra brand Sarasa Push Clip gel pens, but any gel-based ballpoint pen will work.

These pens draw smoothly and are available in a wide range of vivid colors. Although ballpoint pens are available in dozens of shades, we only used twelve different colors throughout this book.

ABOUT BALLPOINT PENS

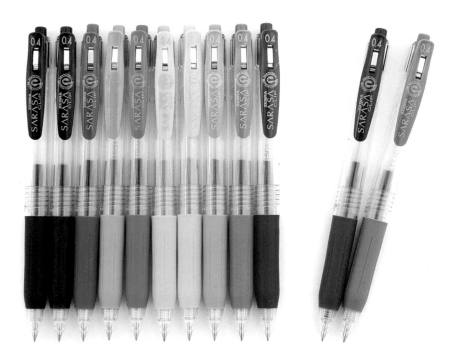

We used black, blue-black, cobalt blue, light blue, green, light green, yellow, orange, pink and red, which are sold as a ten-color set, plus brown and gray, which can be purchased individually.

ABOUT INK

When shopping for ballpoint pens, it's important to check the ink type. Ballpoint pens are available in gel, oil and water-based inks. We prefer gel ink because it combines the advantages of oil and water-based inks.

Oil-Based Ink

- Does not smudge or fade easily
- Heavy writing texture

Water-Based Ink

- Smooth writing texture
- Vivid color
- Bleeds easily
- Runs when wet

Gel-Based Ink

- Dries quickly
- Does not smudge easily
- Smooth writing texture
- Vivid color

ABOUT THICKNESS

The number displayed on each ballpoint pen, such as 0.4 or 0.5, represents the diameter in millimeters of the ball embedded in the point of the pen. When you apply pressure to the pen, the ball rotates, allowing ink to flow out. There are a variety of sizes to choose from, ranging from 0.3 to 1.0 mm, but we recommend using a 0.4 mm ballpoint pen for the drawings in this book.

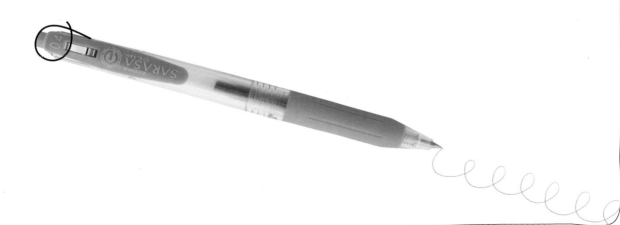

DRAWING TECHNIQUES

In this book, basic illustrations are broken down into four or five easy-to-follow steps. Study each illustration closely and try to replicate it, focusing on the overall shapes and positioning of the lines. If you have trouble with a certain step, place your paper on top of the illustration and trace it a few times. Once you get the hang of it, try drawing the illustration freehand until you are happy with the results.

Once you've mastered the step-by-step technique, have fun drawing cats and dogs in your own style.

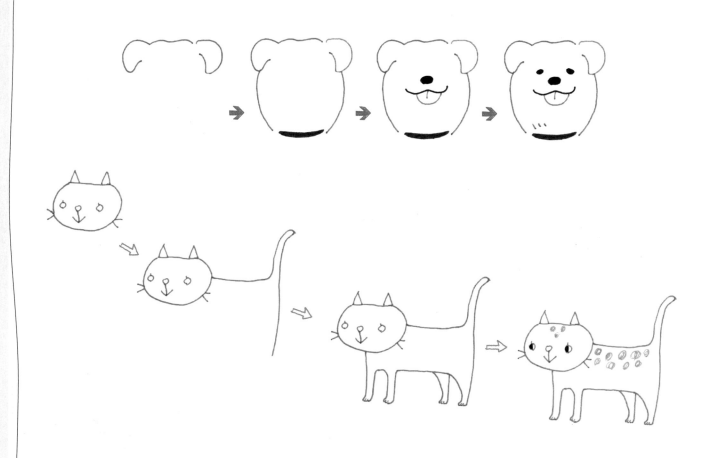

Along the way, you'll see helpful tips
and explanations of the steps.

COLORING TECHNIQUES

There are many different techniques for adding color to your drawings using ballpoint pens. Color contributes to the overall style of your drawing and can also make your drawing look more realistic. Practice the different coloring methods, then choose the one that works best with the style of your drawing.

SOLID

Small areas such as ears and collars can be colored in completely.

LINES

Use lines to fill in larger areas. Combine lines of different angles to create depth.

Stack rows of fine lines to replicate the direction in which the cat's hair grows.

CIRCLES

Circular lines produce a fluffy texture and can make your drawing look like a stuffed animal.

Layer fine circular lines to create the look of long fur.

THE COLOR LAYERING METHOD

If you don't have a purple pen, layer pink and cobalt blue to produce the perfect shade of grape.

Adding some red on top of orange produces an intense color that conveys the heat of the sun.

Layer pink and red to create a three-dimensional strawberry. (Light green and green were also layered for effect.)

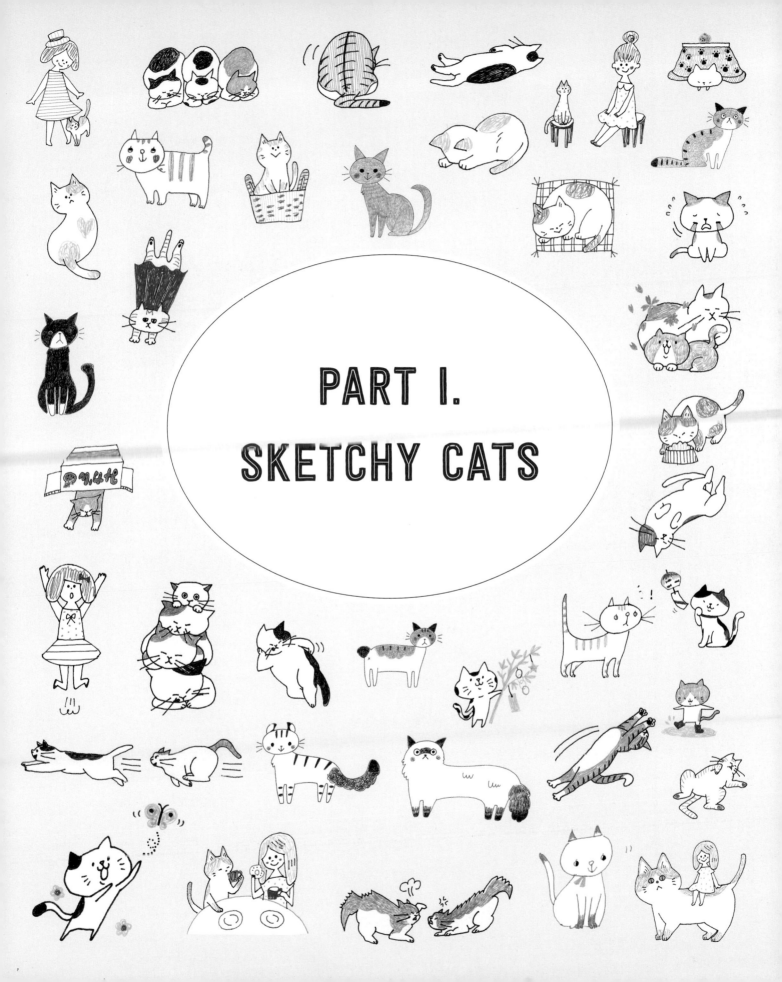

PART I.
SKETCHY CATS

CATS: THE BASICS

We'll start out by introducing the basic elements of drawing cats. First, we'll learn how to draw the face and body, then we'll move on to some common cat expressions.

THE FACE

By combining just a few simple shapes, you'll be able to draw a cat face in no time!

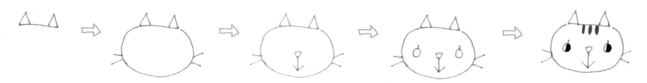

Draw two triangles for ears and connect them with a line.

Draw a circle for the outline of the face and add whiskers.

Draw the nose at the center of the face, then add lines for the mouth.

Draw apple shapes for the eyes.

Add some color to complete the cat's face.

CHANGE THE PERSPECTIVE

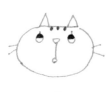

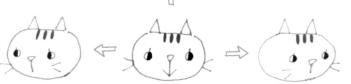

Up
Position the eyes and other facial features toward the top of the face.

Right
Position the facial features toward the right side of the face.

Left
Position the facial features toward the left side of the face.

Down
Position the eyes toward the bottom of the face. (It's alright if the mouth is not visible.)

ADD SOME COLOR

Use two different colors for the ears.

Add stripes to the cheeks and forehead.

Use bold colors for a fun look.

TRY SOME VARIATIONS

Changing just one component of the face will give the cat a completely different look. Experiment with the face shape and features to create many different types of cats.

FACE SHAPE

Oblong

Square

Puffy cheeks

EYES

Closed

Wide open

Tightly closed

Sleepy

Surprised

EARS

Small

Medium

Large

Scared

Listening

NOSE & MOUTH

Smiling

Serious

No mouth

THE BODY

Now, let's practice drawing the body. The key is to use curved lines to express a cat's soft, fluid shape.

SITTING DOWN

Front View

Back View

Side View

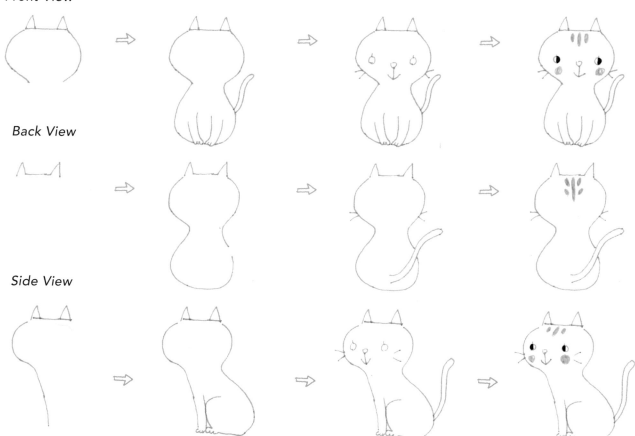

SIMPLER OPTION

You may find it difficult to draw the legs when first starting out. Try some of these cat poses that don't involve drawing legs.

 Try a position of lying down backwards.

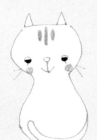 Hide the legs with the tail.

 Draw the cat wearing a dress.

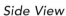

STANDING UP

Side View

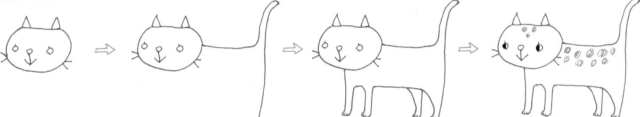

Front View

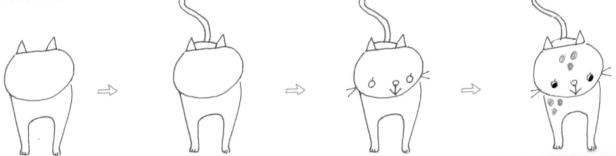

Back View

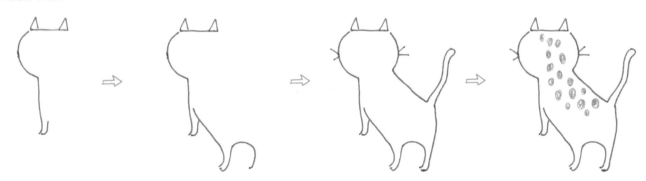

TRY SOME VARIATIONS

Once you master drawing the body, try adding some accessories for a playful look.

Draw a ribbon on the head.

Add some socks.

Add a decoration on the tail.

WALKING

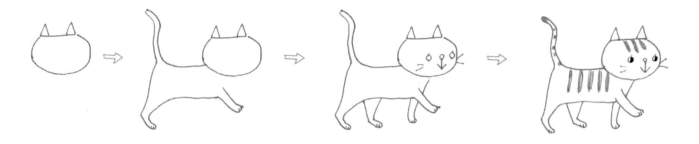

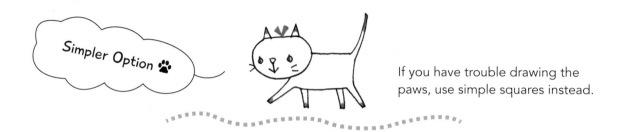

Simpler Option

If you have trouble drawing the paws, use simple squares instead.

CLOSE-UP: THE TAIL & PAWS

Let's take a minute to focus on drawing the tail and paws, which are two of the most important parts of a cat's body.

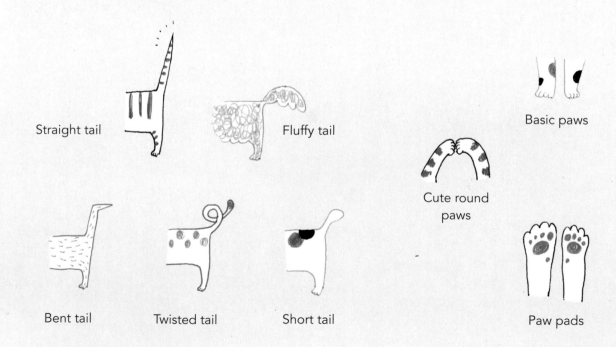

Straight tail

Fluffy tail

Basic paws

Cute round paws

Bent tail

Twisted tail

Short tail

Paw pads

TRY SOME VARIATIONS

Make a few simple changes to transform a basic cat into a cat with a unique body type.

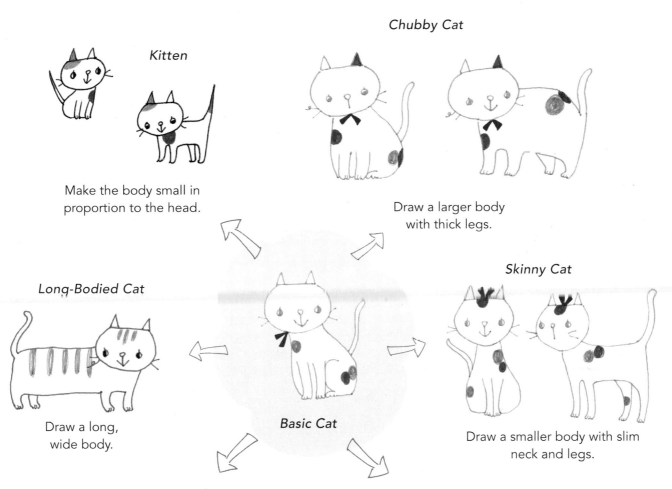

Kitten

Make the body small in proportion to the head.

Chubby Cat

Draw a larger body with thick legs.

Long-Bodied Cat

Draw a long, wide body.

Basic Cat

Skinny Cat

Draw a smaller body with slim neck and legs.

Short-Legged Cat

Make the body larger to emphasize the shortness of the legs.

Long-Haired Cat

Use squiggly lines around the face, tummy and tail for a fluffy look.

EXPRESSIONS

Let's practice drawing a variety of expressions commonly displayed by cats. Try to convey the emotion in both the cat's facial expression and body language.

CALM

A sitting body and a peaceful face indicate a calm cat.

FRIENDLY

An inclined head signifies a friendly greeting.

RELAXED

Closed eyes and a dreamy expression convey a relaxed attitude.

HAPPY

A smiling face and an upright tail signify happiness.

SLEEPY

This cat is starting to doze off!

LISTENING

This cat may be facing backwards, but his alert ears and tail indicate that he's listening intently.

ALERT

A cat's entire body goes stiff when nervous.

SURPRISED

Cats freeze in their tracks when surprised.

SCARED

Cats may curl up in a ball when scared.

INTIMIDATED

Bared teeth and hair standing on end reveal that a cat is intimidated.

EMBARRASSED

Cats tuck their tails between their legs when embarrassed.

FRUSTRATED

With cats, a wagging tail can signify irritation.

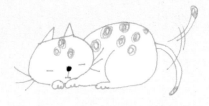

IN A BAD MOOD

If your cat's refusing to make eye contact, he or she may be in a bad mood.

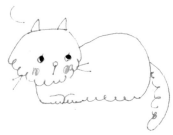

IN A TERRIBLE MOOD

If your cat is in a really bad mood, he or she may ignore you completely!

CATS IN ACTION

These illustrations capture cats' daily activities, from sleeping and stretching to grooming and playing. Let's practice drawing cats in a variety of poses.

SLEEPING

Sleeping ranks among cats' favorite activities. Remember to incorporate calm facial expressions when drawing cats who are sleeping peacefully.

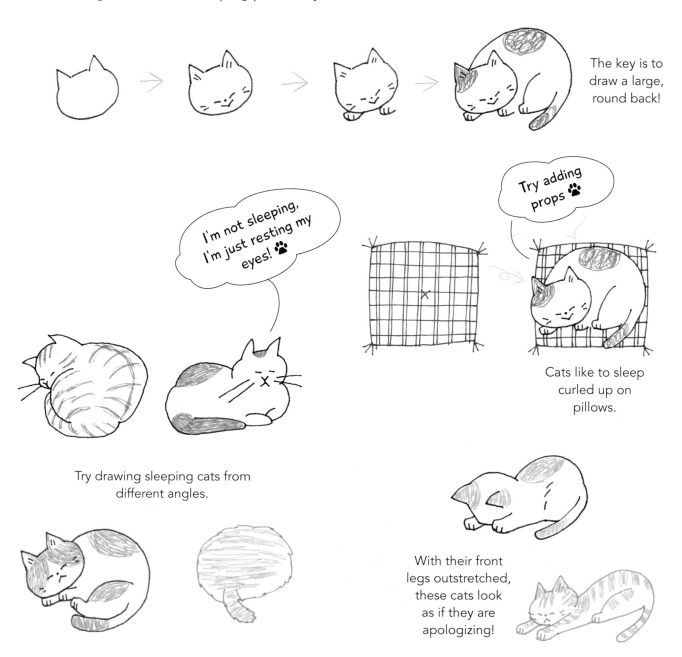

The key is to draw a large, round back!

I'm not sleeping, I'm just resting my eyes! 🐾

Try adding props 🐾

Cats like to sleep curled up on pillows.

Try drawing sleeping cats from different angles.

With their front legs outstretched, these cats look as if they are apologizing!

These cats are sound asleep!

This cat is resting his head on a pillow, just like a human.

This cat looks very comfortable in a hammock.

In Japan, cats love to sleep on *kotatsus*, which are heated tables covered with blankets.

PLAYING

Cats love to chase moving objects and climb into high (and sometimes dangerous) places.

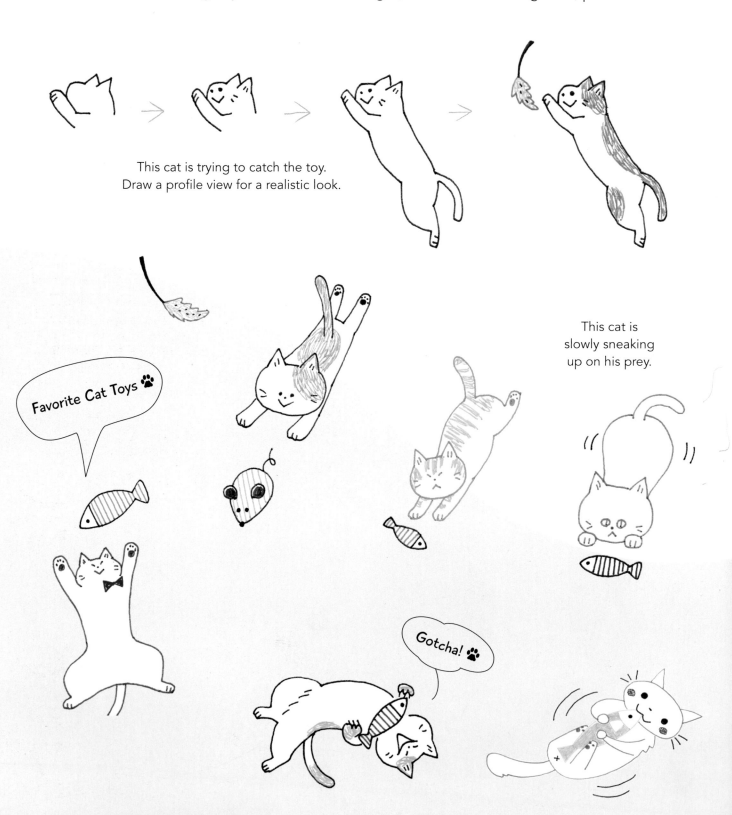

This cat is trying to catch the toy.
Draw a profile view for a realistic look.

Favorite Cat Toys

This cat is slowly sneaking up on his prey.

Gotcha!

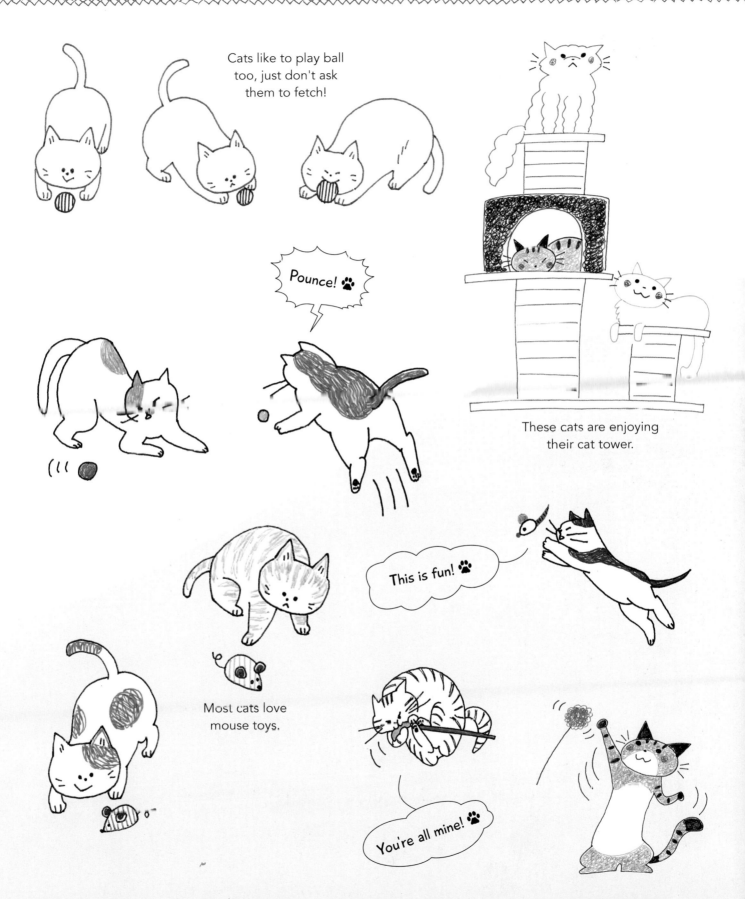

Cats like to play ball too, just don't ask them to fetch!

These cats are enjoying their cat tower.

Pounce! 🐾

This is fun! 🐾

Most cats love mouse toys.

You're all mine! 🐾

STRETCHING

Cats are notorious for their yoga-like stretching routines. Focus on the curved lines of the body and the content facial expressions when drawing these poses.

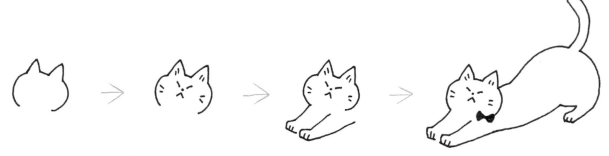

Draw extended front legs and a raised rear end to capture the classic cat stretching pose.

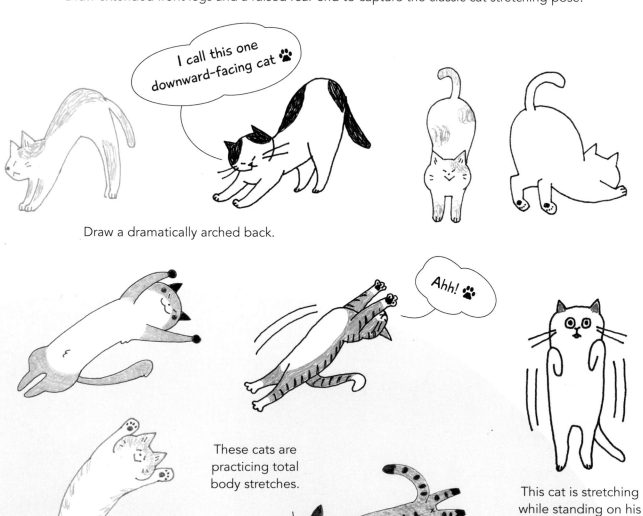

I call this one downward-facing cat 🐾

Draw a dramatically arched back.

Ahh! 🐾

These cats are practicing total body stretches.

This cat is stretching while standing on his two back legs.

GROOMING

Cats take great pride in their appearance, and they aren't shy about grooming in public.

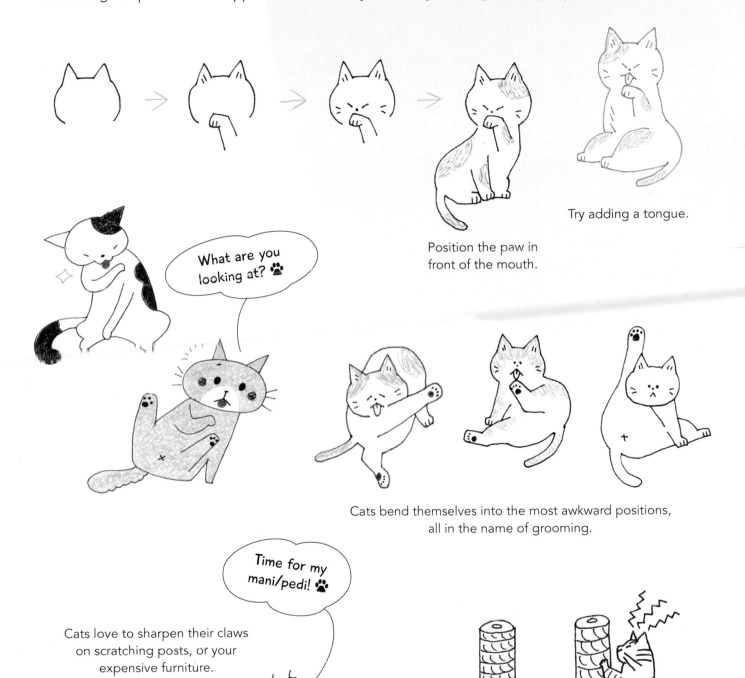

Try adding a tongue.

Position the paw in front of the mouth.

What are you looking at? 🐾

Cats bend themselves into the most awkward positions, all in the name of grooming.

Time for my mani/pedi! 🐾

Cats love to sharpen their claws on scratching posts, or your expensive furniture.

EATING

Some cats may be picky eaters, but the ones pictured here love food (for the most part).

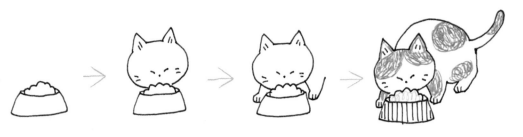

Draw the feet planted firmly on the ground and the face almost buried in the food dish.

Various Cat Foods

Bon appetit! 🐾

Leave me alone! 🐾

If a cat turns her back on you while eating, it's a good idea to leave her alone.

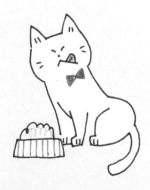

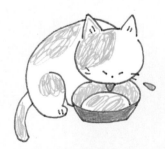

Cats use their tongues to lap up water.

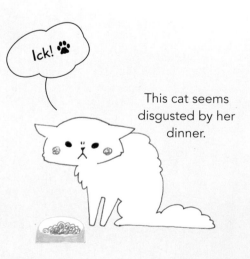

Ick! 🐾

This cat seems disgusted by her dinner.

RELAXING

Cats have certainly mastered the art of relaxation. Practice drawing cats sprawled out in some comfortable spots.

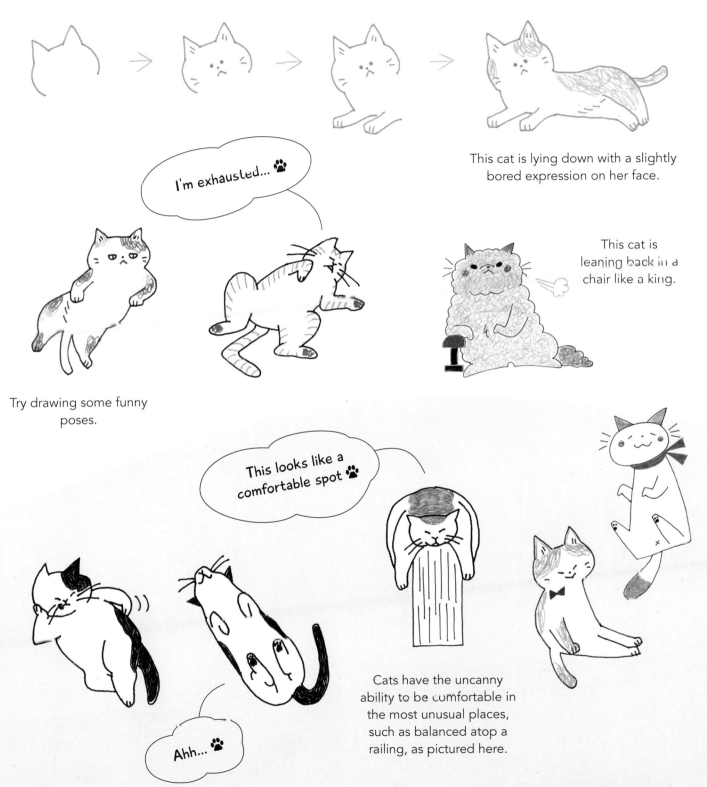

This cat is lying down with a slightly bored expression on her face.

I'm exhausted...

This cat is leaning back in a chair like a king.

Try drawing some funny poses.

This looks like a comfortable spot

Ahh...

Cats have the uncanny ability to be comfortable in the most unusual places, such as balanced atop a railing, as pictured here.

STARING

Sometimes cute, sometimes creepy, you'll often catch cats staring.

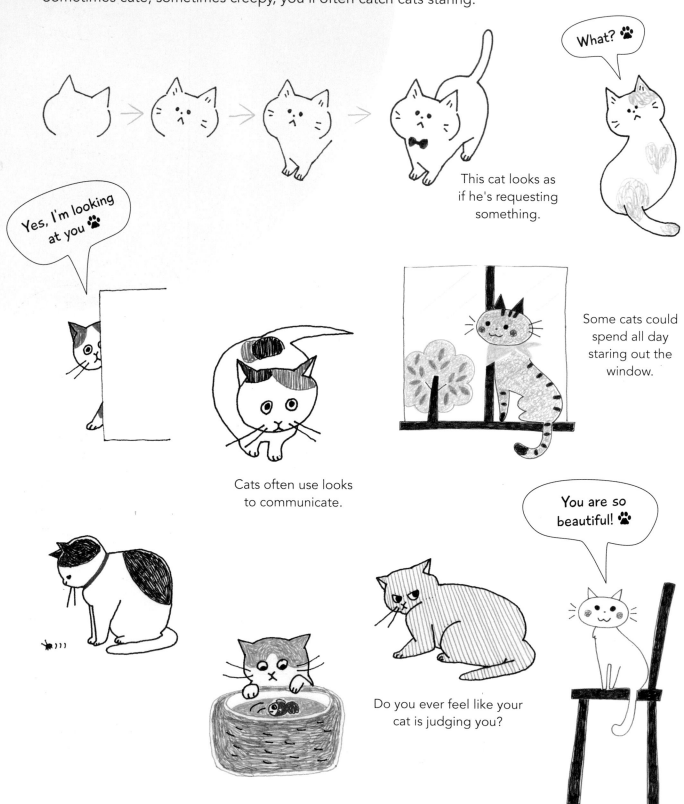

What? 🐾

This cat looks as if he's requesting something.

Yes, I'm looking at you 🐾

Some cats could spend all day staring out the window.

Cats often use looks to communicate.

You are so beautiful! 🐾

Do you ever feel like your cat is judging you?

CATS IN WEIRD PLACES

What is it about a cardboard box that cats find so irresistible? Let's practice drawing cats in the unusual places where they love to hide.

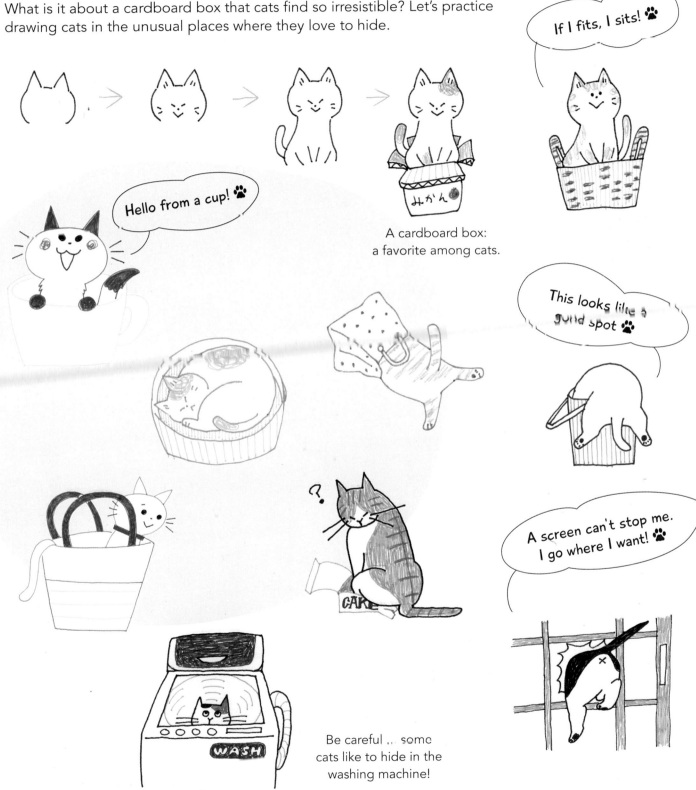

A cardboard box: a favorite among cats.

Be careful ... some cats like to hide in the washing machine!

DOING ACROBATICS

Cats are known for being quite acrobatic and flexible. They can jump high and far in graceful displays of athleticism.

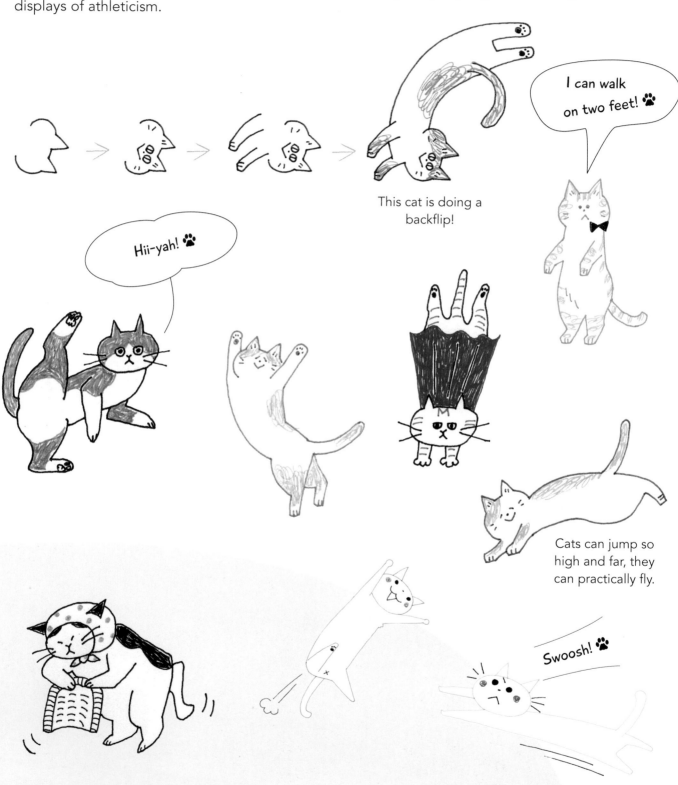

This cat is doing a backflip!

I can walk on two feet! 🐾

Hii-yah! 🐾

Cats can jump so high and far, they can practically fly.

Swoosh! 🐾

RANDOM CAT SITUATIONS

This collection of illustrations features unique situations.

Time for the vet!

Dogs bury bones,
cats bury poop.

HANGING OUT

You never know what will happen when cats get together. They may cuddle up together or act territorial. Let's draw some scenes of socialization in the cat world.

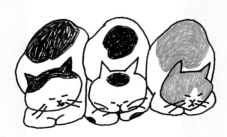

Here are three little kitties in a row.

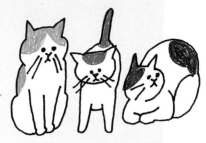

These three cats are just hanging out.

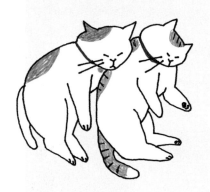

These two kitties are snuggling.

Cat pile!

Slurp!

Time for a grooming session!

Wait!

These two cats are enjoying a friendly game of tag.

These feline buddies are giving each other Eskimo kisses!

It looks like things are about to get ugly.

Cat fight!

Cat-tastic! 🐾

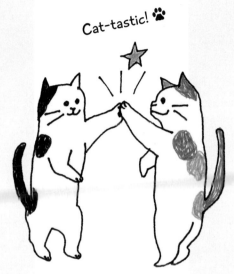

Cat high five!

Caught you! 🐾

Cat headlock!

Look at us! 🐾

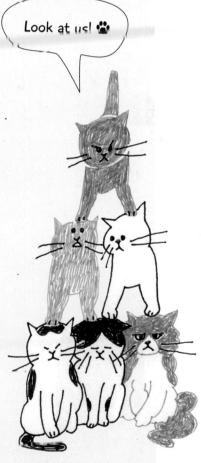

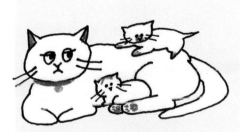

This mama cat is snuggling with her kittens.

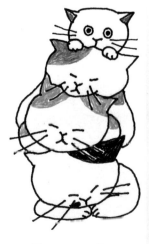

These cats form a totem pole.

Now that's what I call a cat tower.

CATS & PEOPLE

Let's take a break from drawing cats for a minute and practice drawing humans. Cats are companion animals, so it's important to be able to draw cats interacting with their owners.

THE BODY

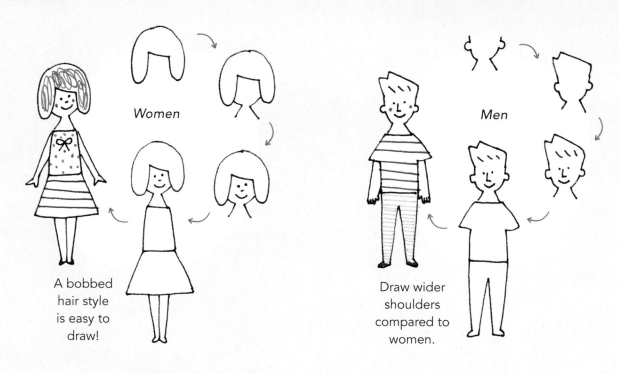

Women

A bobbed hair style is easy to draw!

Men

Draw wider shoulders compared to women.

HAIRSTYLES & FACIAL EXPRESSIONS

Women

Long Short Wavy Bun

Men

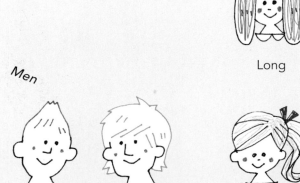

Spiky Long Ponytail Braids With glasses With a hat

IN ACTION

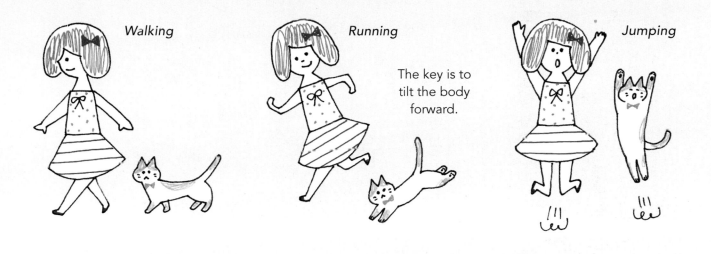

Walking

Running

The key is to tilt the body forward.

Jumping

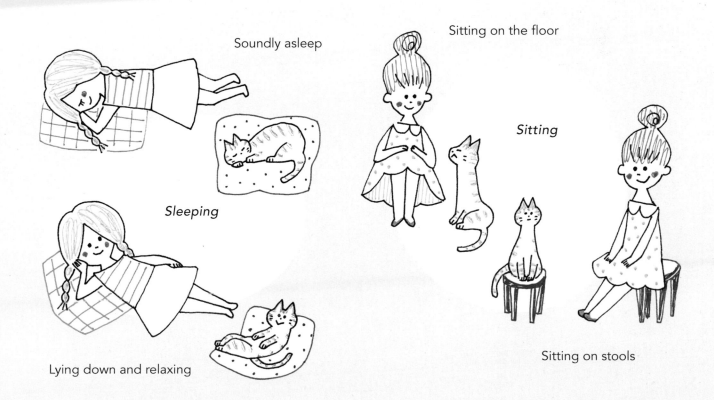

Soundly asleep

Sitting on the floor

Sleeping

Sitting

Lying down and relaxing

Sitting on stools

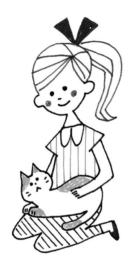

Cat on the lap

Cat on the shoulder

Cat on the head

Petting underneath the chin

Holding the cat

Cat trying to get attention

Cat rubbing against your leg

Cat trying to play while you're sleeping

Lying down with your cat

Playing with your cat

Tea time with your cat

Riding your cat

TYPES OF CATS

There are so many different types of cats in the world, each with their own unique coloring and patterns. In this chapter, we'll cover some basic patterns common among domestic cats. Then, we'll learn how to draw specific cat breeds.

PATTERNS

When coloring, keep in mind the direction in which the hair grows in order to create a realistic-looking cat drawing.

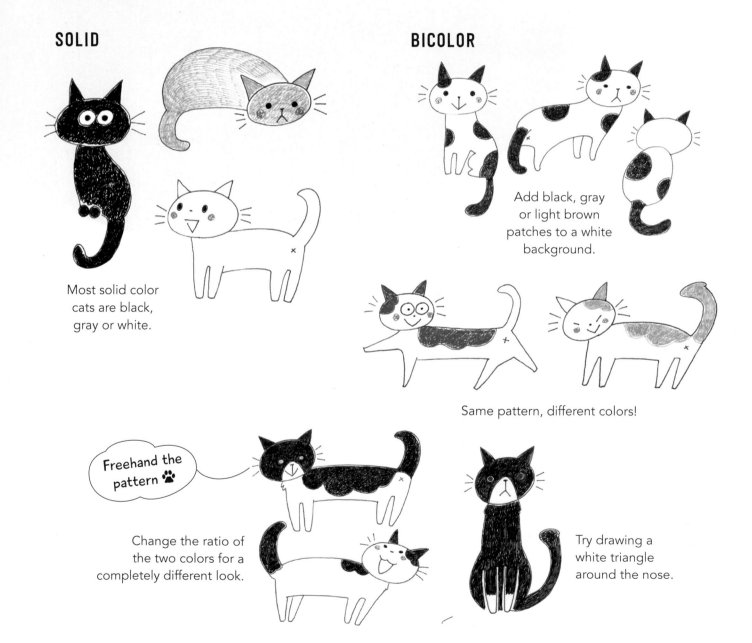

SOLID

Most solid color cats are black, gray or white.

BICOLOR

Add black, gray or light brown patches to a white background.

Same pattern, different colors!

Freehand the pattern 🐾

Change the ratio of the two colors for a completely different look.

Try drawing a white triangle around the nose.

CALICO

Draw patches of brown and black onto a white cat (position the brown and black patches next to each other for a realistic look).

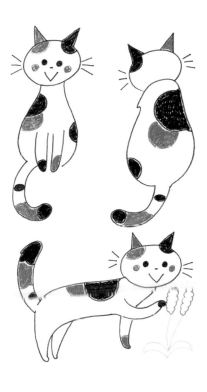

TABBY

Add stripes to the forehead, back, legs and tail.

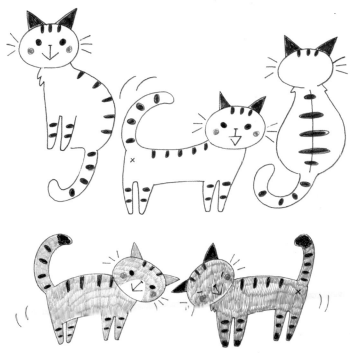

Same pattern, different colors!

TORTOISESHELL

Layer black lines on top of orange to create a tortoiseshell effect.

SOCKS

A dark body and white feet form a cute pattern that looks as if the cat is wearing socks.

BREEDS

Now, we'll learn how to draw some of the most popular cat breeds. We'll start with short-haired cats, then move onto long-haired ones. When drawing, focus on the unique characteristics of the breed.

American Shorthair
Draw a swirled pattern on the body.

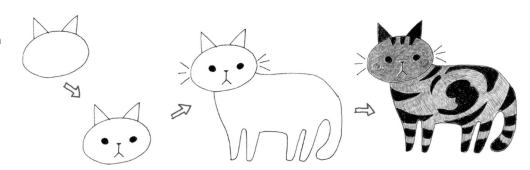

Scottish Fold
Draw a round face with flat ears that fold toward the front.

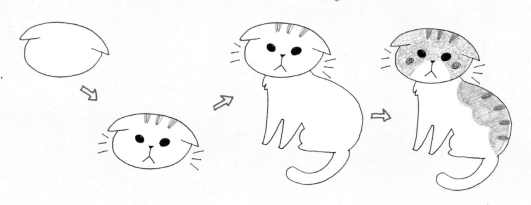

Munchkin
These cats have short legs, leading them to be nicknamed "the Dachshunds of cats."

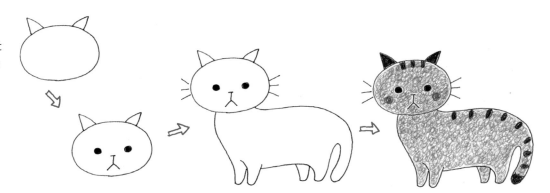

Russian Blue
These cats are known for their slim bodies and blue-gray fur. When coloring, keep in mind the direction in which the fur grows.

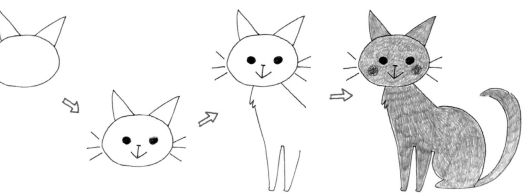

Siamese
Leave the body white, but color the ears, paws and tail brown. These cats have beautiful blue eyes.

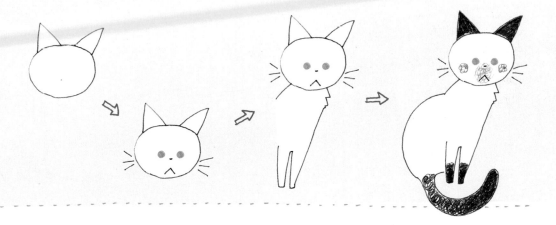

Bengal
These cats are known for their leopard-like spots. Although they look wild, these cats are actually quite friendly and social.

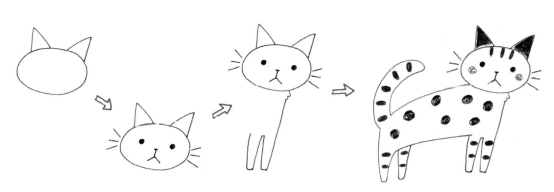

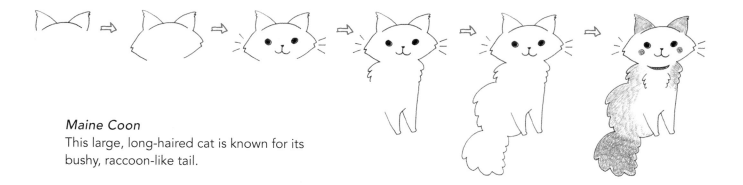

Maine Coon
This large, long-haired cat is known for its bushy, raccoon-like tail.

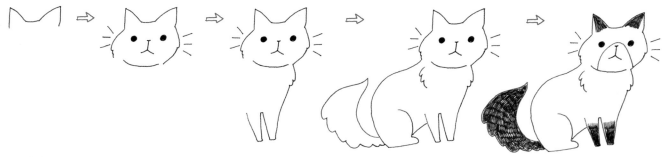

Ragdoll
These cats have luxurious coats, with color on their ears, paws and tails.

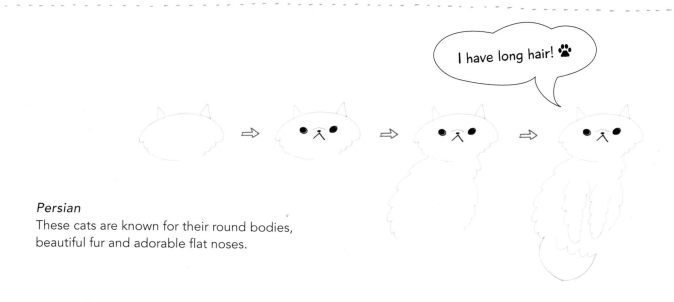

I have long hair! 🐾

Persian
These cats are known for their round bodies, beautiful fur and adorable flat noses.

TRY SOME VARIATIONS

Here are a few more popular cat breeds. Which one is your favorite?

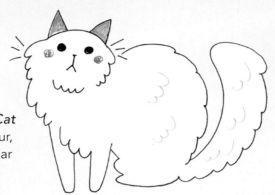

Norwegian Forest Cat
With luxurious long fur, this breed has a similar appearance to the Maine Coon cat.

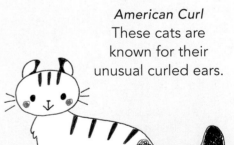

Abyssinian
Draw large, pointed ears and a slender, graceful body. These cats have beautiful, silky coats that shine when they move.

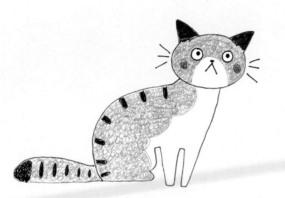

Exotic Shorthair
This cat is a cross between a Persian and an American Shorthair. Make sure to draw the flat nose characteristic of a Persian cat.

Japanese Bobtail
These cats are known for their unusual bobbed tails that resemble rabbit tails.

American Curl
These cats are known for their unusual curled ears.

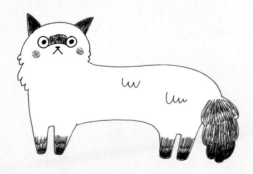

Himalayan
A cross between the Persian and Siamese, these easygoing cats have short legs and long hair.

Singapura
One of the smallest cat breeds, Singapuras have big eyes and shiny fur.

SKETCHY CATS

In this section, you'll learn how to draw cat-themed borders, icons and seasonal motifs. Use these quick and easy cat illustrations to decorate letters, cards and calendars.

SILHOUETTES

Draw cat outlines in a variety of poses, then fill the illustrations in with solid colors for a bold, graphic look.

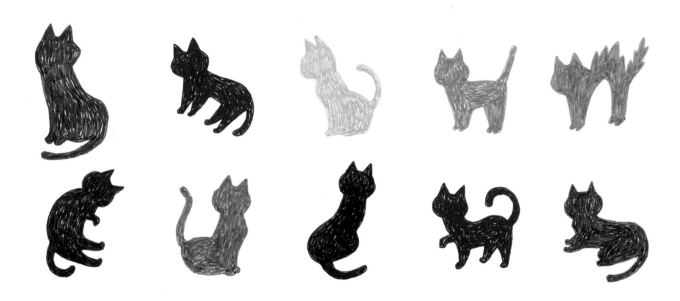

PUTTING IT ALL TOGETHER

Create beautiful, professional-looking illustrations by incorporating other objects into your cat silhouette doodles.

BORDERS

Draw continuous repeats of a single motif or incorporate lines into your illustrations to create decorative borders.

Draw three straight lines to form a road connecting a cat and a house.

Alternate between simple squares and cat faces to form this checkerboard pattern.

This little cat is peeking out from behind a fancy lace border.

It looks like the cat is chasing after the dots in this fun border design.

Use a decorative ribbon to connect these two dapper cats.

This colorful border features cats and flowers ... a classic combination!

Draw a variety of simple cat faces to create this colorful design.

This playful border features an unravelling ball of yarn and one very happy cat.

Combine a michievous cat with a trail of footprints to form this adorable border.

This sweet border was inspired by cats frolicking in a field.

FRAMES

Use these frames to decorate a sheet of paper or to outline an important message.

These two cats look as if they are engaged in a game of chase!

This design incorporates a cat's favorite food: fish. Use a simple color scheme for a bold look.

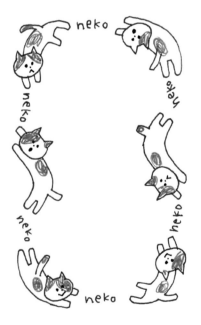

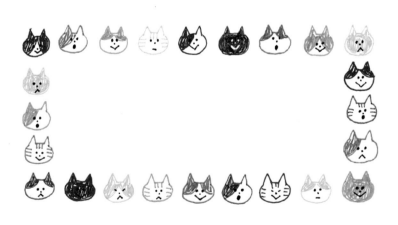

Jumping cats create a fun, active frame. Did you know *neko* is the Japanese word for cat?

The many faces of a cat: Use bright, primary colors for a cheerful look.

Combine decorative elements, such as stars, moons and clouds to create this unique frame.

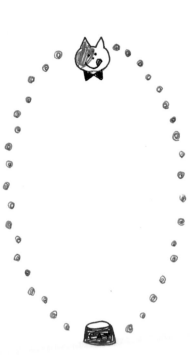

This hungry cat just needs to follow the trail of dots to find his food dish.

This border is quick and easy to draw—just sketch a simple cat, then add a squiggly outline.

Use simple hearts to create a frame for love letters.

Draw the houses in a variety of sizes for a dynamic look.

This design would work well in just about any shape.

LETTERS & NUMBERS

Don't forget to add style to your letters and numbers.

Draw solid bubble letters for a simple, yet bold look. It doesn't matter whether you use round or pointy corners, just be consistent.

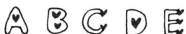

For a decorative look, try filling your block letters with a pattern, such as stripes. Have fun experimenting with different color combinations.

Try outlining your letters in a darker color to create a shadow. Then, add some brightly colored highlights to make the text pop.

Use hearts or other fun shapes to fill holes or embellish the tips of each letter.

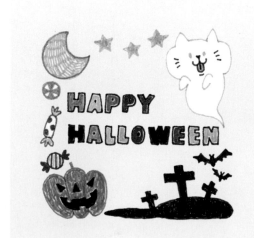

INCORPORATE TEXT INTO YOUR DRAWING

This Halloween-themed illustration features multicolor letters.

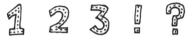

For a bright, playful look, try alternating colors for each character.

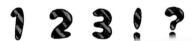

Draw dashed lines inside each character to create a hand-stitched look.

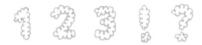

Use squiggly lines to create a soft, fluffy impression.

Fill each character with diagonal stripes for a bold font that suggests movement.

CAT CHARACTERS

For those of you who are completely cat-obsessed, try using cat-related images to create pictorial fonts.

It's all about teamwork ... these cats are working together to create these fun letters.

Look closely—little pawprints form each letter in this font.

CAT CHARACTERS

Try drawing cats as characters. Use facial expressions, body language and clothing to express each character's personality.

DRAW CHARACTERS

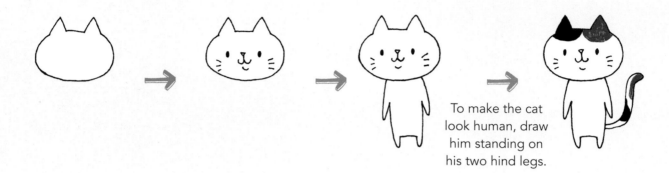

To make the cat look human, draw him standing on his two hind legs.

TRY DIFFERENT EXPRESSIONS

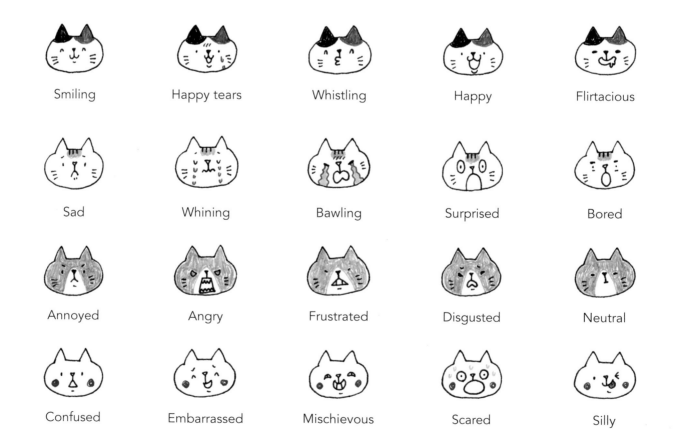

Smiling	Happy tears	Whistling	Happy	Flirtacious
Sad	Whining	Bawling	Surprised	Bored
Annoyed	Angry	Frustrated	Disgusted	Neutral
Confused	Embarrassed	Mischievous	Scared	Silly

Add Clothes

Add clothing to give each cat its own unique personality.

Add Captions

I am a cat, hear me roar! 🐾

Add a fun caption to complete the illustrations.

TRY DIFFERENT POSES

Startled
This cat is so startled that his heart is about to jump out of his chest!

Skipping
Between the humming and the spring in his step, you can tell that this is one happy cat.

Celebrating
This cute cat is celebrating a personal victory with a double fist pump.

Crying
Angle the ears downward and cast a shadow on her back to express this cat's sadness.

Laughing
This cat is laughing so hard that he's actually crying.

Sleeping
For a sleeping cat, daw a relaxed facial expression and comfortable pose.

Exhausted
This poor cat is out of breath.

SENTIMENTS

Use these cute cat icons to design your own cards. Each of these cats has a special message to deliver.

GREETINGS

Hi! 🐾

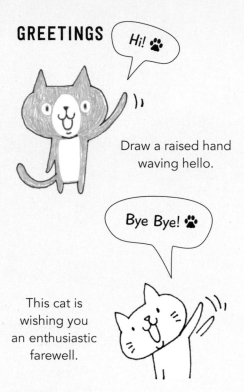

Draw a raised hand waving hello.

Bye Bye! 🐾

This cat is wishing you an enthusiastic farewell.

THANK YOU

This cat is bowing to express his deep gratitude.

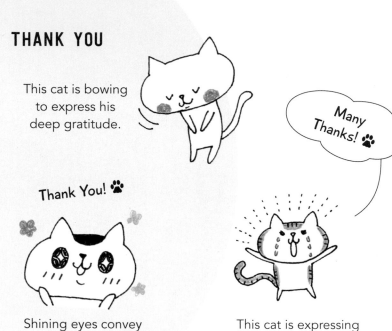

Many Thanks! 🐾

Thank You! 🐾

Shining eyes convey this cat's happiness and appreciation.

This cat is expressing gratitude with every inch of his body.

SORRY

This little cat feels terrible about the situation.

Oops! 🐾

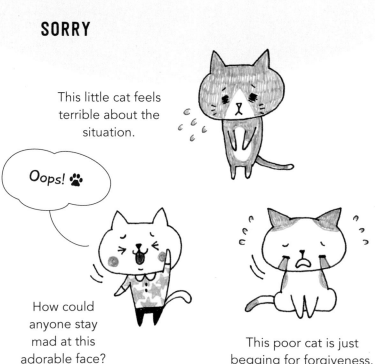

How could anyone stay mad at this adorable face?

This poor cat is just begging for forgiveness.

ENCOURAGEMENT

Fight!

This cat is your biggest cheerleader.

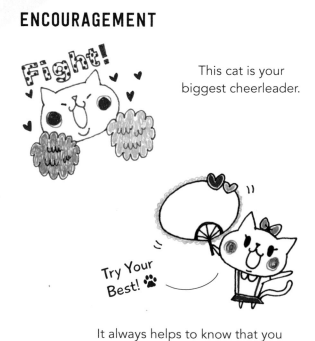

Try Your Best! 🐾

It always helps to know that you have a friend in your corner.

NICE WORK

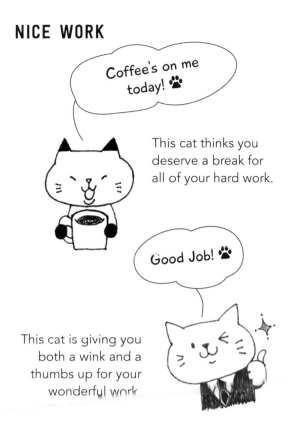

This cat thinks you deserve a break for all of your hard work.

This cat is giving you both a wink and a thumbs up for your wonderful work.

WILL YOU DO ME A FAVOR?

With every fiber of his being, this cat is praying you'll help him.

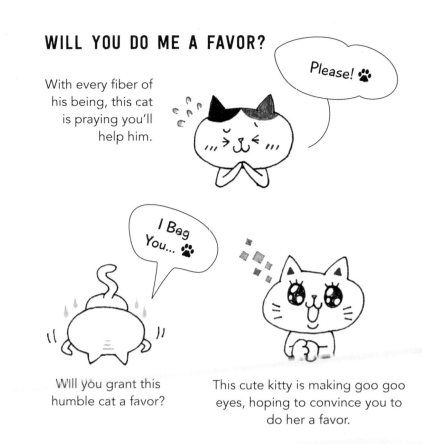

Will you grant this humble cat a favor?

This cute kitty is making goo goo eyes, hoping to convince you to do her a favor.

CONGRATULATIONS

Let's get this party started!

What a great friend ... this cat wants to celebrate your success.

REPLIES

Message recieved ... loud and clear.

Just leave it to me ... I'll handle this.

That's one cool cat.

This cat is giving you the OK symbol.

HOLIDAYS & SPECIAL EVENTS

These illustrations were inspired by holidays and other special events. Use these motifs for cards, gift tags and holiday decorations.

NEW YEAR'S DAY

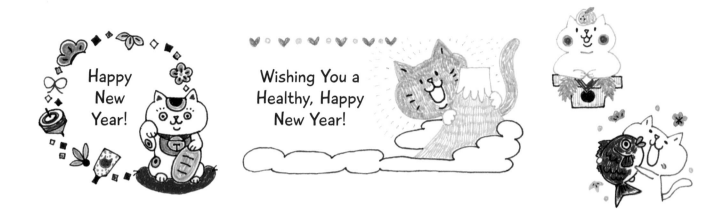

THE CHINESE ZODIAC

In our opinion, it's a shame that the cat isn't one of the twelve Chinese zodiac signs. But don't worry ... we've come up with a way to remedy that oversight. These images feature cats dressed as each zodiac sign.

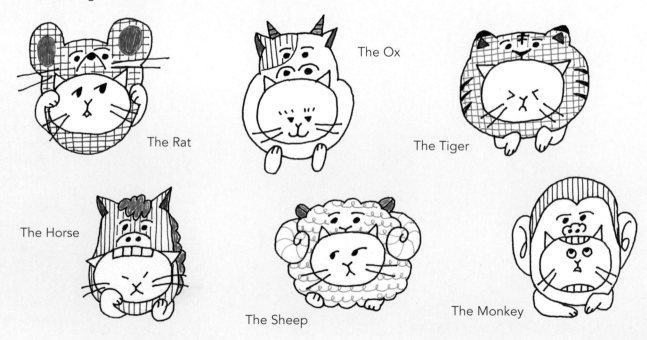

VALENTINE'S DAY

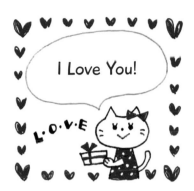

HALLOWEEN

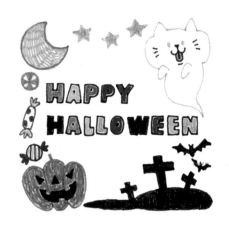

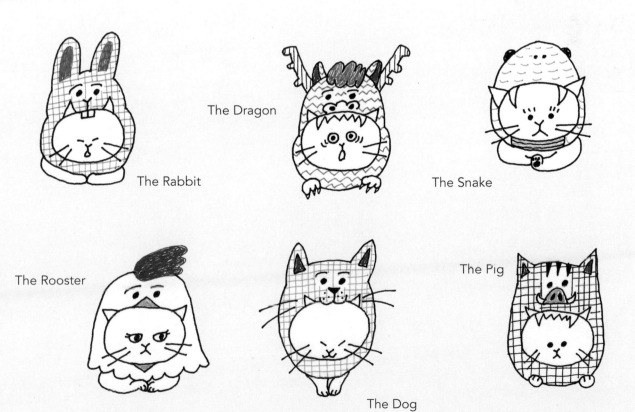

The Rabbit

The Dragon

The Snake

The Rooster

The Dog

The Pig

CHRISTMAS

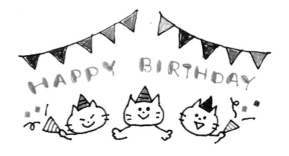

BIRTHDAY

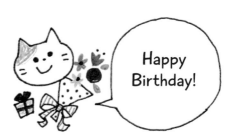

WEDDINGS

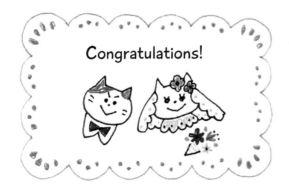

Congratulations!

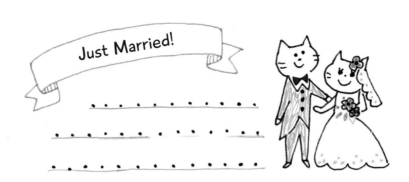

Just Married!

MOVING

We've Moved!

EDUCATION & EMPLOYMENT

NOTES & MEMOS

This collection of illustrations is designed for taking messages and leaving notes. They can be used at the office, at home or in your appointment book.

MESSAGE MEMOS

While You Were Out:

GIFT TAGS

PARTY INVITATIONS

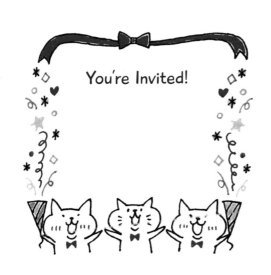

You're Invited!

Party!

Cheers!

MINI ICONS

Important!

Urgent!!

Needs to be
checked!

Come back
to this later!

TO DO LIST

to do

CALENDAR ICONS

Use these illustrations to decorate your calendar or appointment book.

 Birthday

 Anniversary

 Dinner

 Tea

 Drinks

 Cooking class

 Spa

 Manicure

 Haircut

 Gym

 Date

 Sports game

 Concert

 Movie

 Shopping

 Diet

 Doctor's appointment

 Dentist appointment

 Payday

 Day off

 Meeting

 Study group

 Vacation

 Deadline

 Assignment

CALENDARS

Make time management more exciting by adding doodles to your calendars and appointment books. You can also add illustrations to sticky notes and bookmarks to help keep yourself organized.

Features illustrations on pages 57 and 58.

NOTEBOOKS

Transform run-of-the-mill office supplies into custom works of art by adding cat illustrations. Just cut out an assortment of your favorite sketches and glue or tape them to a store-bought notebook.

Features illustrations on pages 19, 21, 22, 26, 29, 30 and 31.

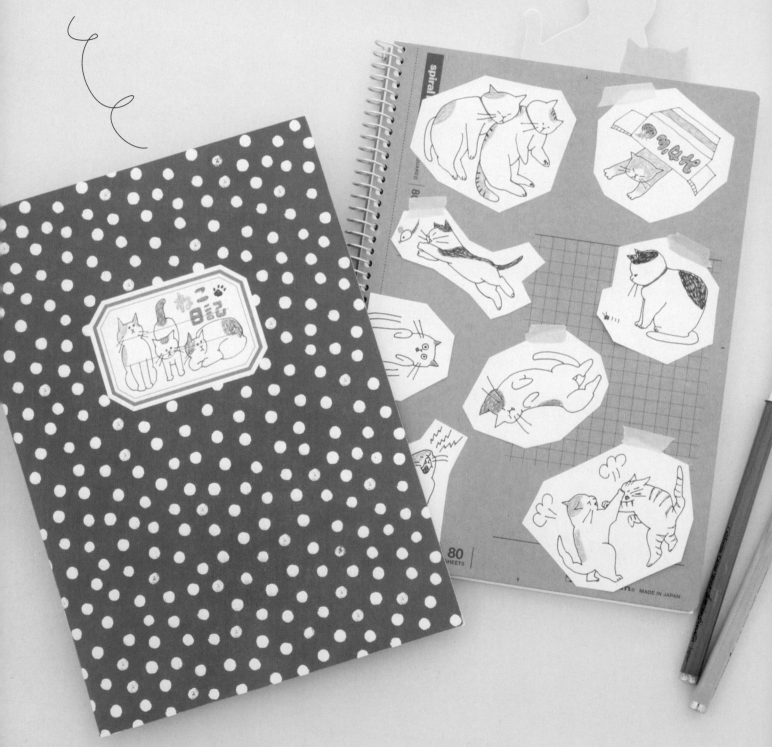

POSTCARDS

To design your own postcards, just cut sheets of colorful paper to size, then decorate with cat illustrations. All of the illustrations in this book will work well, but try using the border and frame motifs on pages 43–45.

Features illustrations on pages 27, 33, 36 and 37.

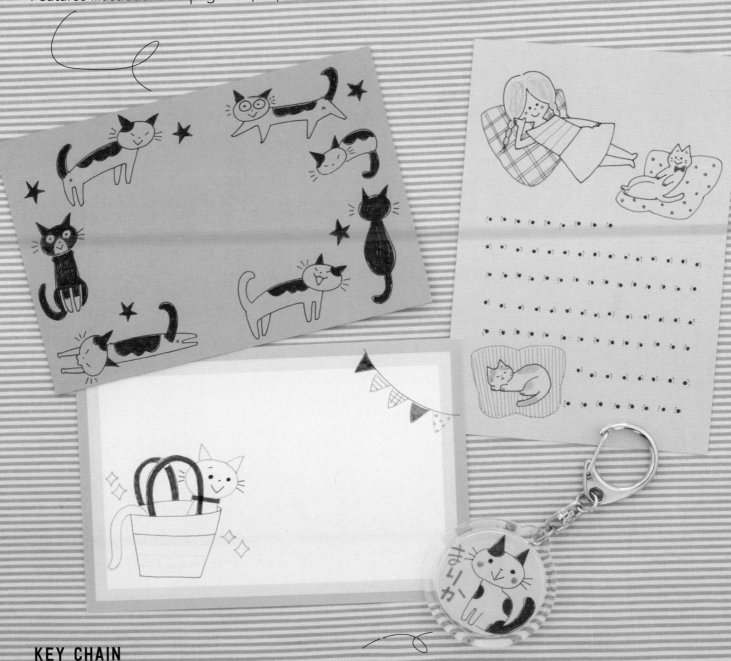

KEY CHAIN

Insert a small cat illustration into a blank keychain and take your pet with you wherever you go!

Features illustration on page 36.

GREETING CARDS

Whether you're celebrating a birthday, holiday, or sending someone you love a special treat, these cat-inspired designs are perfect for any occasion.

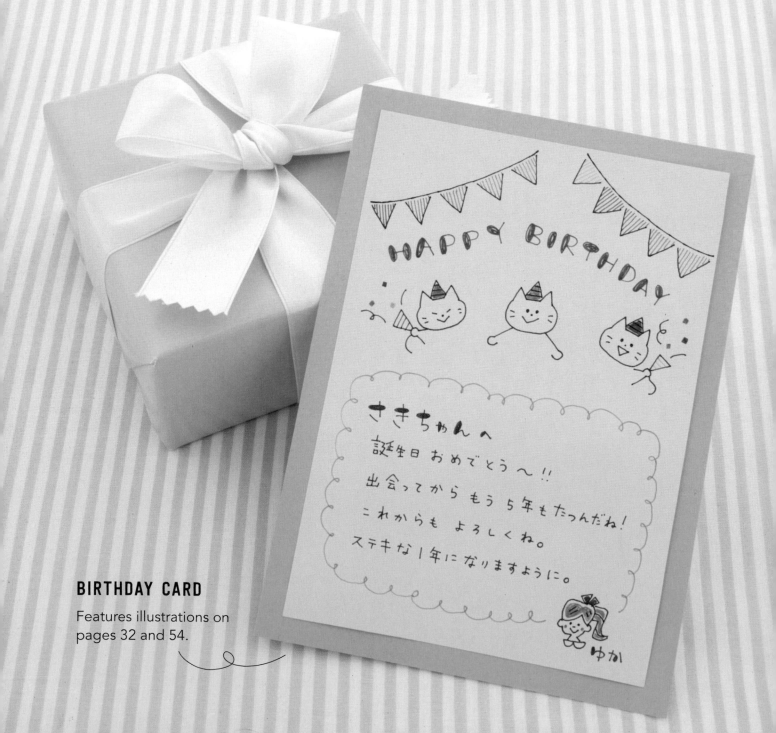

BIRTHDAY CARD

Features illustrations on pages 32 and 54.

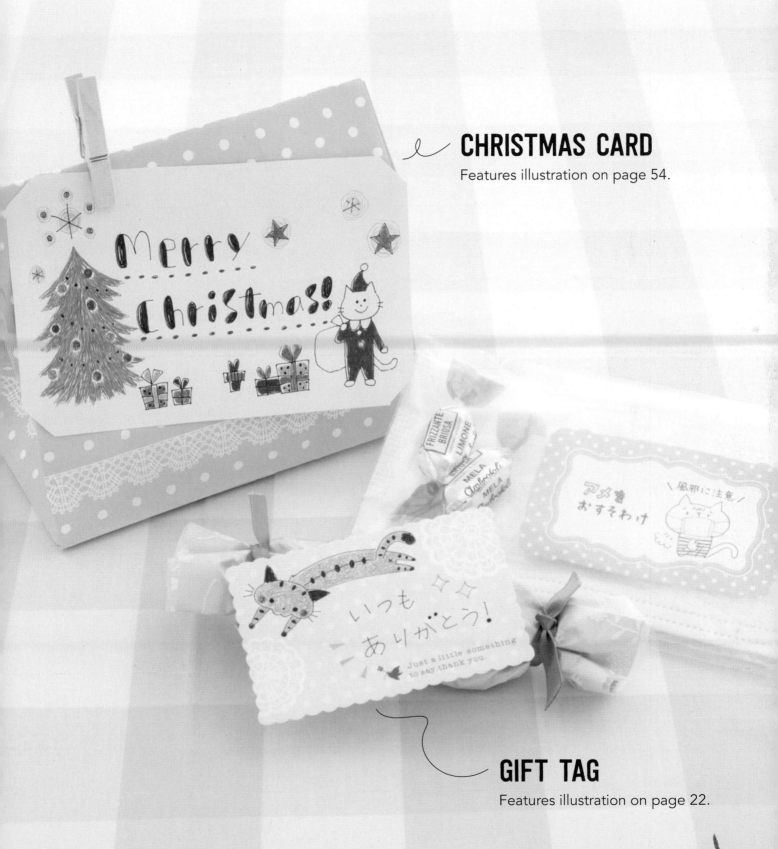

CHRISTMAS CARD

Features illustration on page 54.

GIFT TAG

Features illustration on page 22.

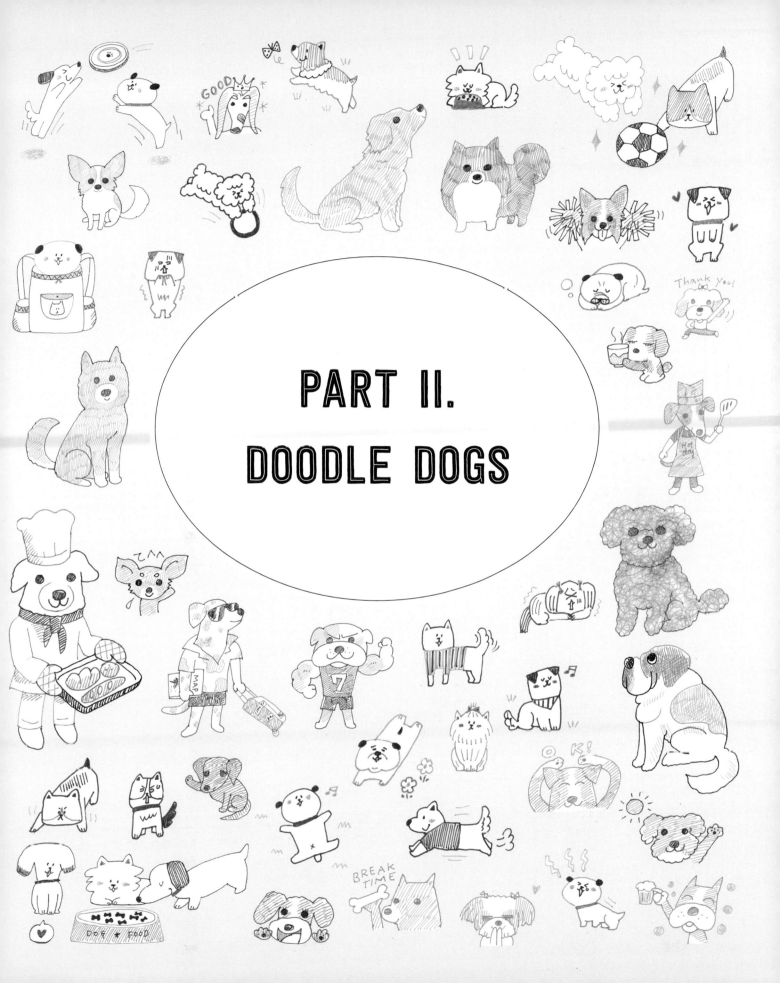

PART II.
DOODLE DOGS

DOGS: THE BASICS

In this section, we'll learn the basics of drawing dogs. Each type of dog has a very distinctive face, so we've provided several different examples. Once you are comfortable drawing basic faces, we'll move on to common dog expressions.

THE FACE

Dog faces can be broken down into a few basic shapes: circles, triangles and squares. The types of lines you use will also play an important part in making your drawings look realistic—use squiggly lines for fluffy dogs and long, angled lines for shaggy dogs.

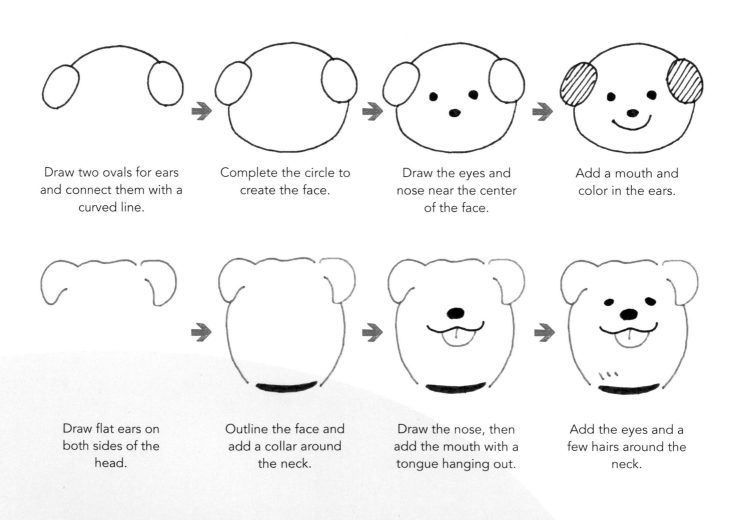

Draw two ovals for ears and connect them with a curved line.

Complete the circle to create the face.

Draw the eyes and nose near the center of the face.

Add a mouth and color in the ears.

Draw flat ears on both sides of the head.

Outline the face and add a collar around the neck.

Draw the nose, then add the mouth with a tongue hanging out.

Add the eyes and a few hairs around the neck.

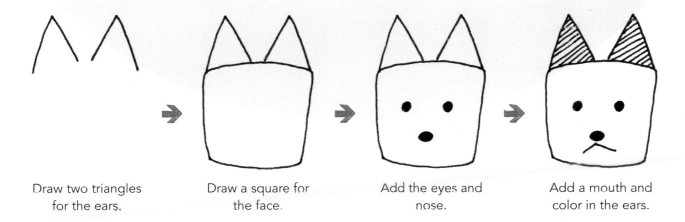

Draw two triangles for the ears.

Draw a square for the face.

Add the eyes and nose.

Add a mouth and color in the ears.

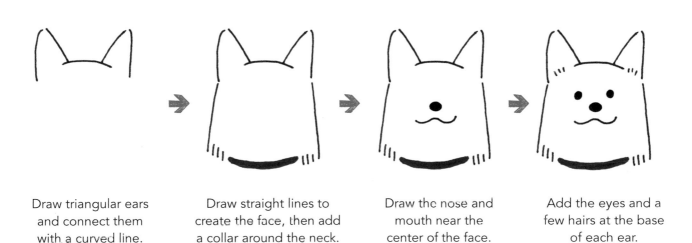

Draw triangular ears and connect them with a curved line.

Draw straight lines to create the face, then add a collar around the neck.

Draw the nose and mouth near the center of the face.

Add the eyes and a few hairs at the base of each ear.

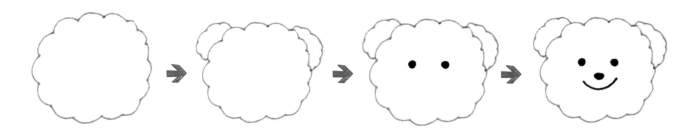

Draw a fluffy circle.

Add the ears.

Draw the eyes near the center of the face.

Add a nose and a smiling mouth.

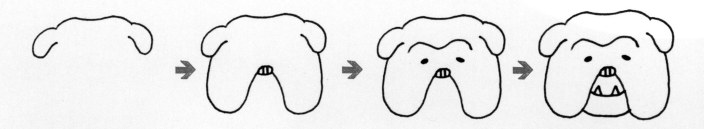

Draw wing-shaped ears.

Outline the face using long lines to replicate the look of shaggy fur.

Draw the nose near the center of the face, then add an open mouth.

Add the eyes.

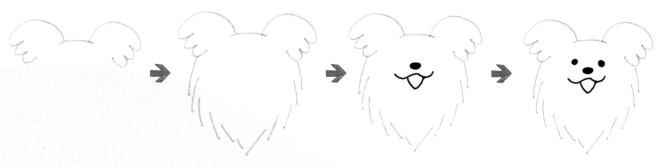

Draw flat ears on both sides of the head.

Draw saggy cheeks that hang down on both sides of the face.

Add the eyes, then draw a wavy wrinkle on top for the forehead.

Add the mouth and teeth.

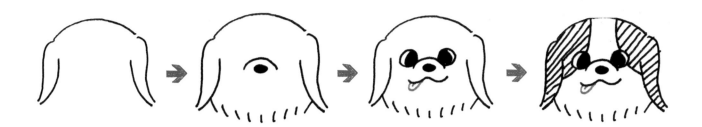

Draw long, thin, flat ears on both sides of the head.

Use short lines to draw the chin, then add the nose.

Draw the eyes and a mouth with the tongue hanging out.

Add some lines to create patterned fur.

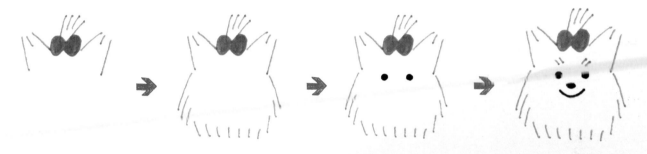

Draw pointy ears and a bow with some fur sticking out.

Outline the face using angled lines to replicate the look of long fur.

Draw round circles for the eyes.

Add the eyebrows, nose and mouth.

EXPRESSIONS

Just like humans, dogs can feel happy, sad and a whole range of other emotions. You can incorporate subtle tricks into your drawings to convey these emotions through a dog's facial expression.

HAPPY

Narrow eyes and an open mouth make a dog look as if he's smiling.

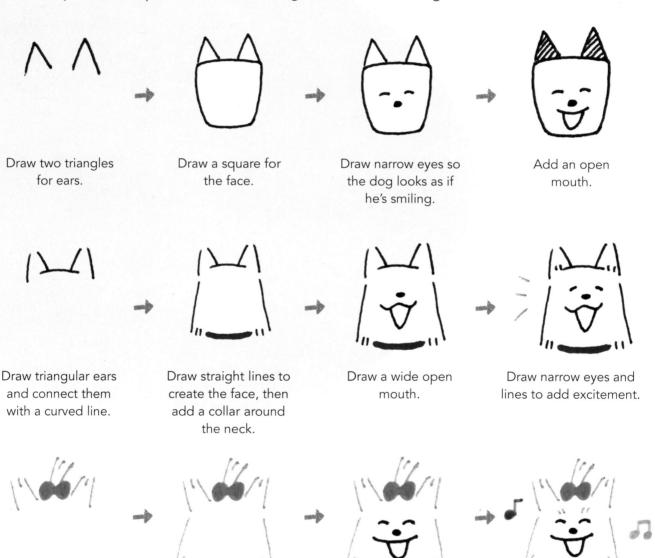

Draw two triangles for ears.

Draw a square for the face.

Draw narrow eyes so the dog looks as if he's smiling.

Add an open mouth.

Draw triangular ears and connect them with a curved line.

Draw straight lines to create the face, then add a collar around the neck.

Draw a wide open mouth.

Draw narrow eyes and lines to add excitement.

Draw ears and fur with a ribbon.

Draw longer fur under the face.

Draw narrow eyes and an open mouth.

Add eyebrows and a few music notes for a cheerful look.

SAD

Details such as furrowed eyebrows, watery eyes and teardrops convey sadness.

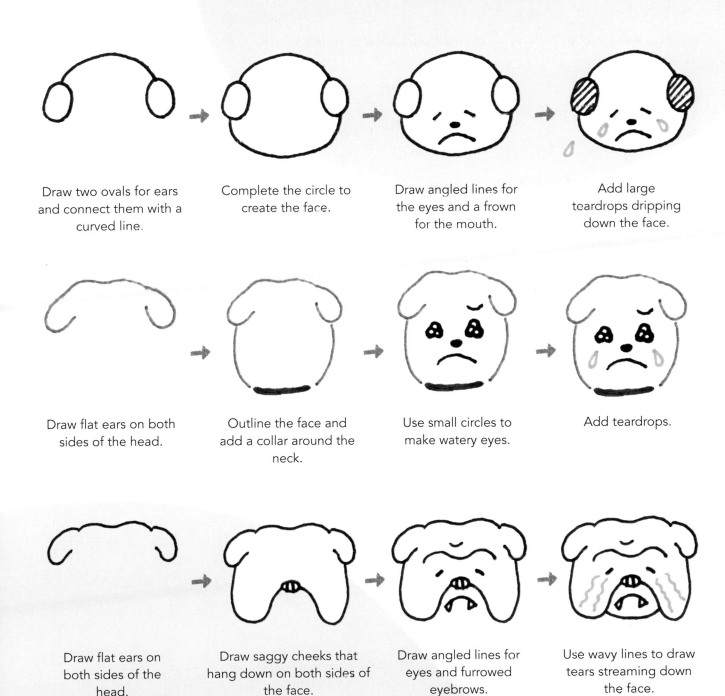

Draw two ovals for ears and connect them with a curved line.

Complete the circle to create the face.

Draw angled lines for the eyes and a frown for the mouth.

Add large teardrops dripping down the face.

Draw flat ears on both sides of the head.

Outline the face and add a collar around the neck.

Use small circles to make watery eyes.

Add teardrops.

Draw flat ears on both sides of the head.

Draw saggy cheeks that hang down on both sides of the face.

Draw angled lines for eyes and furrowed eyebrows.

Use wavy lines to draw tears streaming down the face.

ANGRY

Use sharp, angled lines to express anger. You can also add zigzag lines and puffs of smoke to emphasize the strength of this emotion.

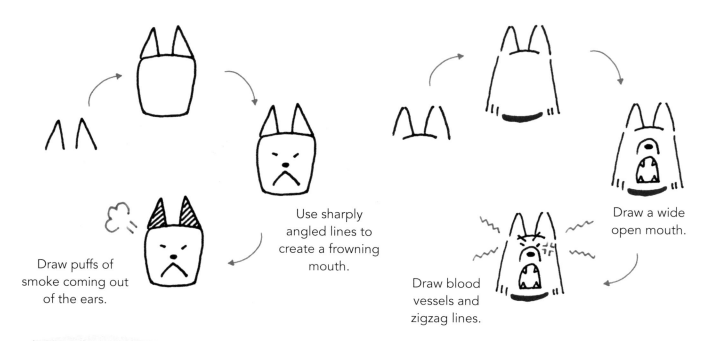

Draw puffs of smoke coming out of the ears.

Use sharply angled lines to create a frowning mouth.

Draw blood vessels and zigzag lines.

Draw a wide open mouth.

SCARED

Dogs often shake when scared, so use wavy lines to show movement.

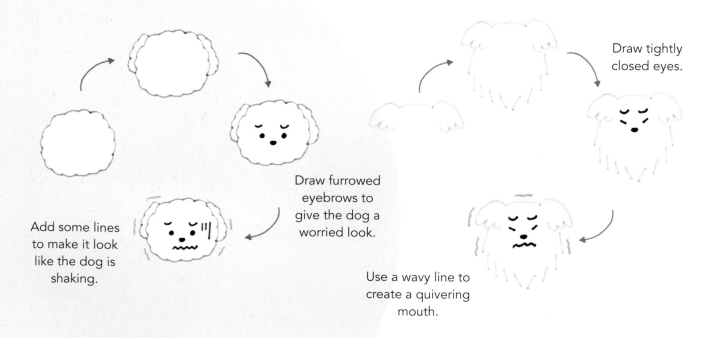

Add some lines to make it look like the dog is shaking.

Draw furrowed eyebrows to give the dog a worried look.

Use a wavy line to create a quivering mouth.

Draw tightly closed eyes.

APOLOGETIC

Dogs often assume an apologetic expression after being scolded. Use frowns and tears to express the regret dogs feel when they disappoint their masters.

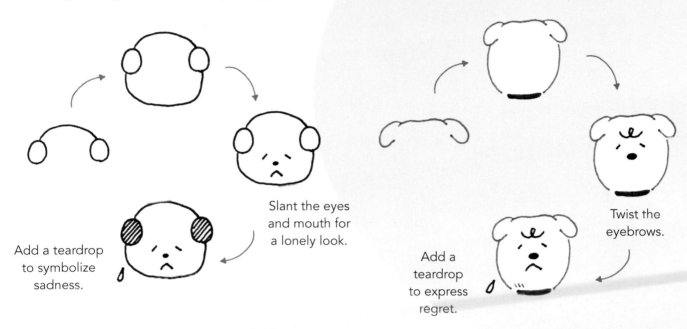

Add a teardrop to symbolize sadness.

Slant the eyes and mouth for a lonely look.

Twist the eyebrows.

Add a teardrop to express regret.

SURPRISED

Wide eyes and open mouths are two common indicators of surprise.

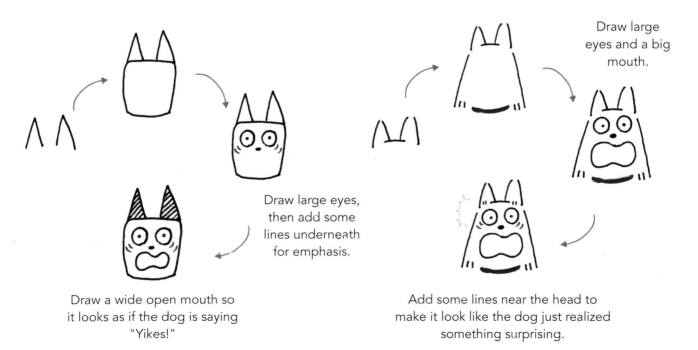

Draw large eyes, then add some lines underneath for emphasis.

Draw a wide open mouth so it looks as if the dog is saying "Yikes!"

Draw large eyes and a big mouth.

Add some lines near the head to make it look like the dog just realized something surprising.

BASHFUL

Add red lines to the cheeks to communicate shyness.

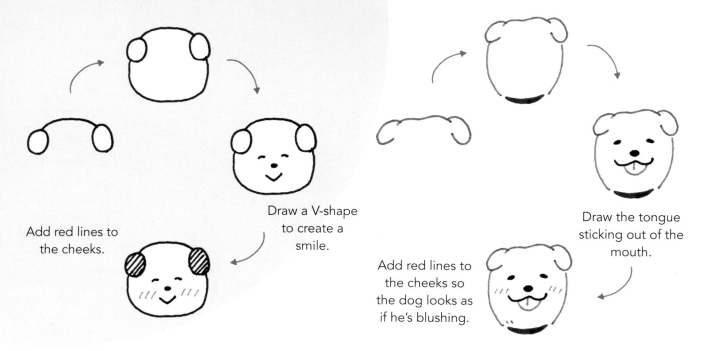

Add red lines to the cheeks.

Draw a V-shape to create a smile.

Draw the tongue sticking out of the mouth.

Add red lines to the cheeks so the dog looks as if he's blushing.

HUNGRY

Draw wide open mouths to show that these dogs are about to dive into their food.

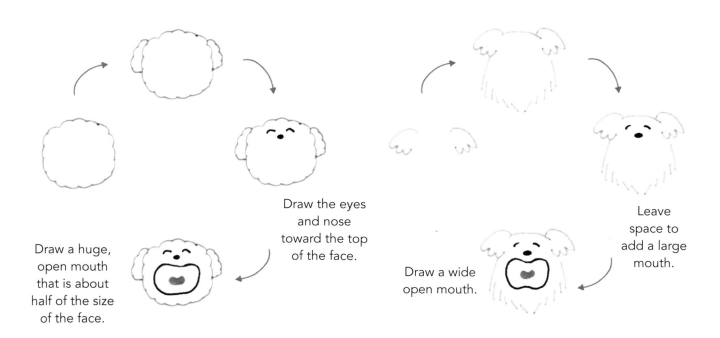

Draw a huge, open mouth that is about half of the size of the face.

Draw the eyes and nose toward the top of the face.

Draw a wide open mouth.

Leave space to add a large mouth.

PLAYFUL

Dogs adopt a unique expression when they want to capture their owner's attention.

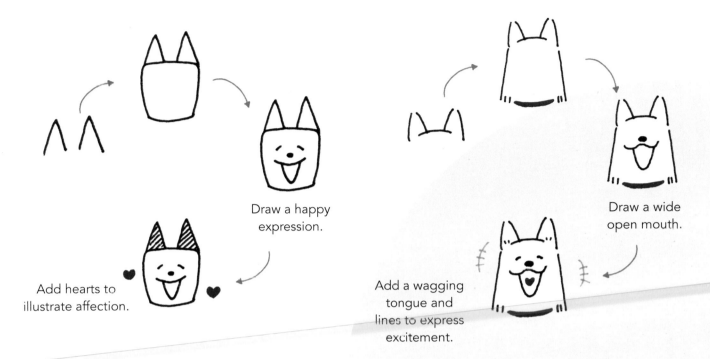

Draw a happy expression.

Add hearts to illustrate affection.

Draw a wide open mouth.

Add a wagging tongue and lines to express excitement.

SLEEPY

Sleeping ranks among dogs' favorite activities. Draw happy faces to show that these dogs are having sweet dreams.

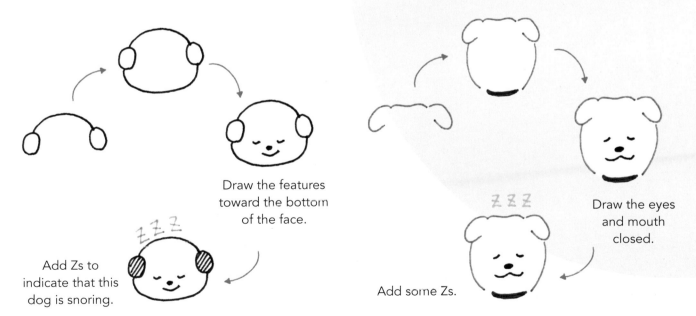

Draw the features toward the bottom of the face.

Add Zs to indicate that this dog is snoring.

Draw the eyes and mouth closed.

Add some Zs.

DOGS IN ACTION

From running and jumping to sniffing and eating, dogs are always on the move. In this section, you'll learn how to draw a variety of dog poses.

STANDING

Front View

This is the most basic dog pose to draw. Let's get started!

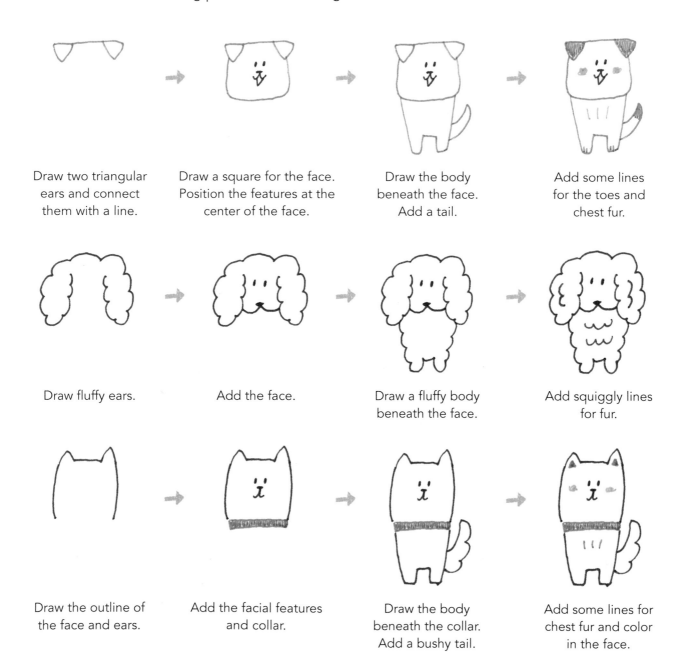

Draw two triangular ears and connect them with a line.

Draw a square for the face. Position the features at the center of the face.

Draw the body beneath the face. Add a tail.

Add some lines for the toes and chest fur.

Draw fluffy ears.

Add the face.

Draw a fluffy body beneath the face.

Add squiggly lines for fur.

Draw the outline of the face and ears.

Add the facial features and collar.

Draw the body beneath the collar. Add a bushy tail.

Add some lines for chest fur and color in the face.

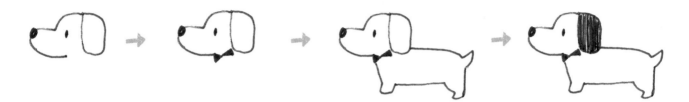

Side View

Now, let's try drawing dogs standing in profile. This pose allows you to practice drawing different body shapes.

Draw a face with a long snout.

Add a bow tie to the neck.

Draw a long body.

Color in the ear.

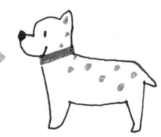

Draw a face with a pointed nose and ear.

Add the mouth and collar.

Draw the body, legs and tail.

Add spots.

Use a squiggly line to draw the outline of the head and ear. Add an eye and nose.

Draw a scarf around the neck.

Draw a fluffy body, legs and tail.

Add more squiggly lines for fluffy fur.

SITTING

Front View

Why are dogs so cute when they are sitting down? Let's draw some well-behaved dogs. The trick to capturing this pose is to align the two front paws.

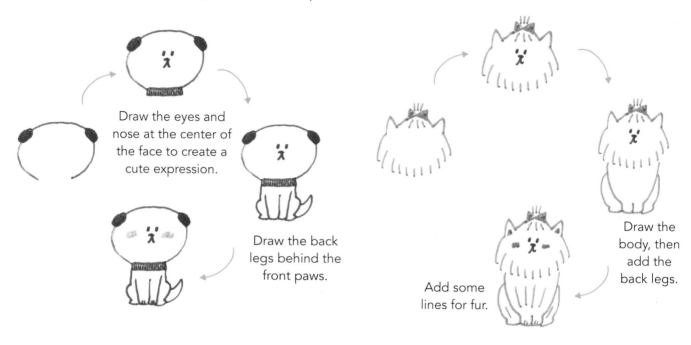

Draw the eyes and nose at the center of the face to create a cute expression.

Draw the back legs behind the front paws.

Draw the body, then add the back legs.

Add some lines for fur.

Side View

These quiet dogs look as if they're waiting for a treat! Make sure to position the face ahead of the front paws so it looks as if they are leaning forward.

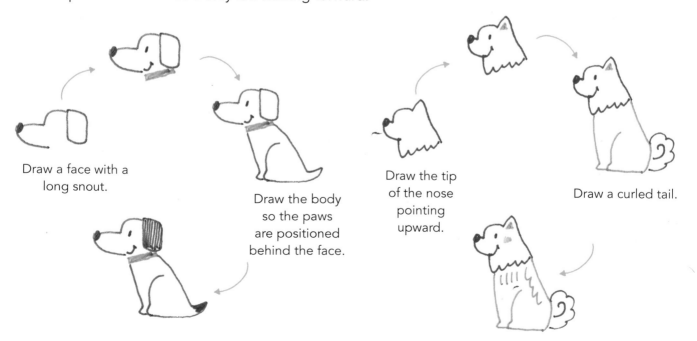

Draw a face with a long snout.

Draw the body so the paws are positioned behind the face.

Draw the tip of the nose pointing upward.

Draw a curled tail.

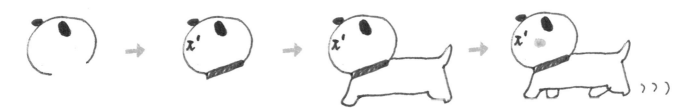

WALKING

Draw long bodies and outstretched legs to express movement. Add little puffs of dust to show that these dogs are on the move.

Draw a round face, even though this dog will be in profile.

Position the eyes and nose toward the left half of the face.

Draw the body with the front and back legs positioned far apart.

Add in the other two legs and some motion lines.

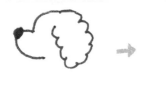

Draw a head with a long snout and a fluffy ear.

Add the face and collar.

Draw the body with an outstretched front leg.

Add in the other two legs and some fluffy fur.

Draw a head with a pointed nose and ear.

Add the face and collar.

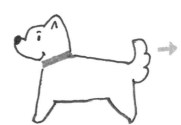

Draw the front and back legs positioned far apart.

Add in the other two legs and some motion lines.

LYING DOWN

Don't forget to draw a happy facial expression since dogs are comfortable when lying down.

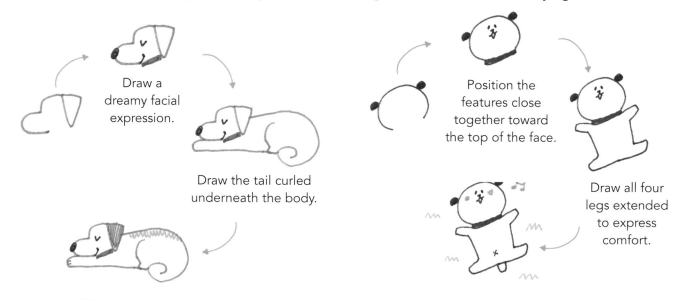

Draw a dreamy facial expression.

Draw the tail curled underneath the body.

Position the features close together toward the top of the face.

Draw all four legs extended to express comfort.

TAIL WAGGING

Tail wagging equals happiness! Use lines to represent the movement of the tail.

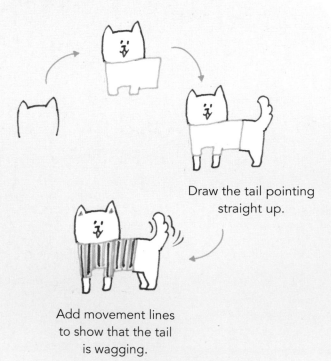

Draw the tail pointing straight up.

Add movement lines to show that the tail is wagging.

DANCING

This dog is doing a trick that involves standing on his back legs. He has a smile on his face because he is expecting a treat as a reward.

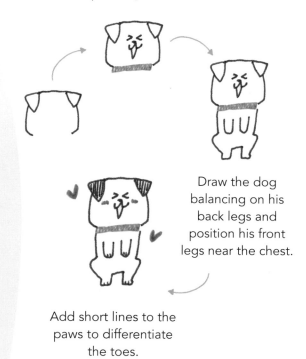

Draw the dog balancing on his back legs and position his front legs near the chest.

Add short lines to the paws to differentiate the toes.

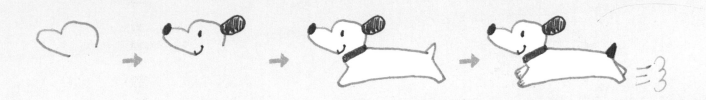

RUNNING

Active dogs love to run! Add lines and puffs of dust to indicate speed.

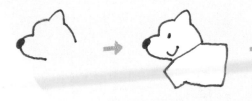 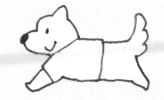 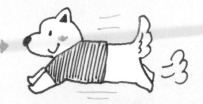

| Draw the outline of the snout and head. | Add the ear and facial features. | Draw a long body with outstretched paws. | Add in the other two paws and a puff of dust. |

Draw the outline
of the snout and
head.

Draw the clothes.

Draw the front
paw and the rest
of the body.

Add in the other two
paws and some lines to
suggest speed.

Use a squiggly
line to draw the
outline of the
head and ear.

Add the facial
features and a collar.

Draw a long body with
outstretched paws.

Add in the other two
paws and a puff of dust.

JUMPING

Dogs often jump up and down when they are excited. You can show excitement through both their body language and facial expressions.

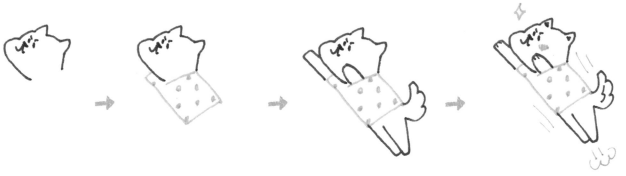

Draw the face looking upward.

Add a cute outfit.

Draw the front legs extending up and the back legs pointing down.

Add some motion lines and puffs of dust to express movement.

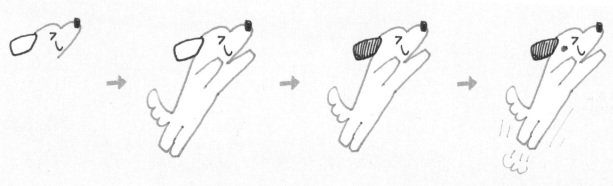

Draw the face looking upward.

Draw the front legs extending up and the back legs pointing down.

Color in the ear.

Add some motion lines and puffs of dust to express movement.

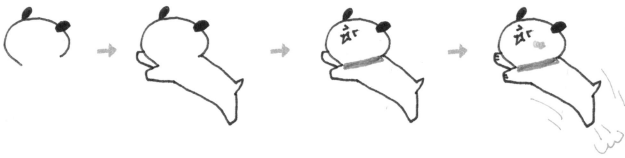

Draw the head with the ears positioned at an angle.

Draw the entire body positioned at an angle as well.

Add the face and a collar.

Add some motion lines and puffs of dust to express movement.

STARTLED

Loud or sudden noises, such as fireworks or even vacuum cleaners, can startle dogs. Use both body language and facial expression to convey surprise.

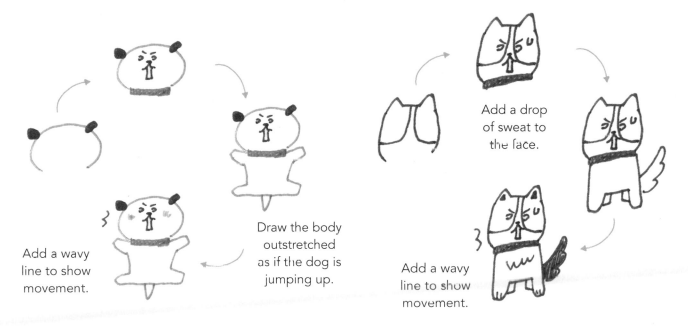

Add a wavy line to show movement.

Draw the body outstretched as if the dog is jumping up.

Add a drop of sweat to the face.

Add a wavy line to show movement.

SHAKING

Dogs often shake when they are afraid. Use the whole body to express the extent of this fearful emotion.

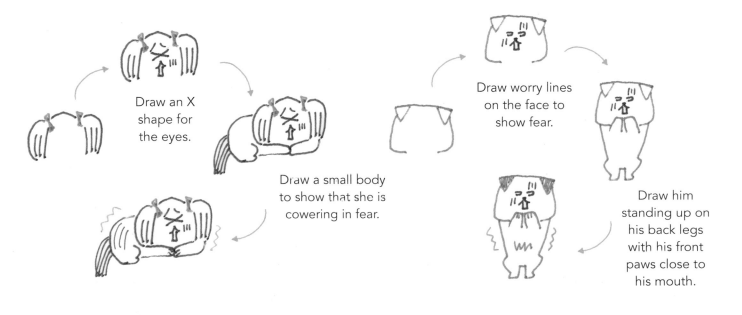

Draw an X shape for the eyes.

Draw a small body to show that she is cowering in fear.

Draw worry lines on the face to show fear.

Draw him standing up on his back legs with his front paws close to his mouth.

PLAYING

Why do dogs love to chase moving objects? Practice drawing dogs playing fetch and chasing other animals.

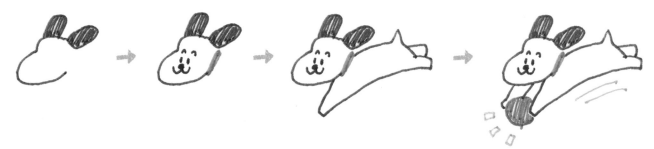

Draw the head and ears positioned at an angle.

Add the face and collar.

Draw one front leg. Draw the back legs stretching upward.

Add in the other front leg and a ball.

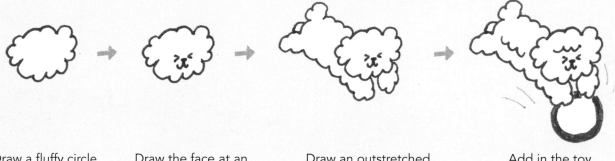

Draw a fluffy circle for the head.

Draw the face at an angle so it is positioned close to the chin.

Draw an outstretched body positioned above the head.

Add in the toy.

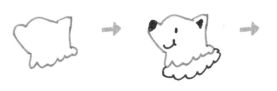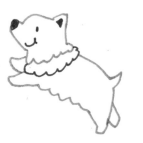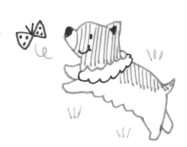

Draw the nose and ear at the same level.

Add the face and some long fur around the neck.

Draw an outstretched body positioned below the head.

Add in some grass and a butterfly to complete the scene.

EATING

Most dogs love to eat. Some wait patiently for their food, while others dive right in.

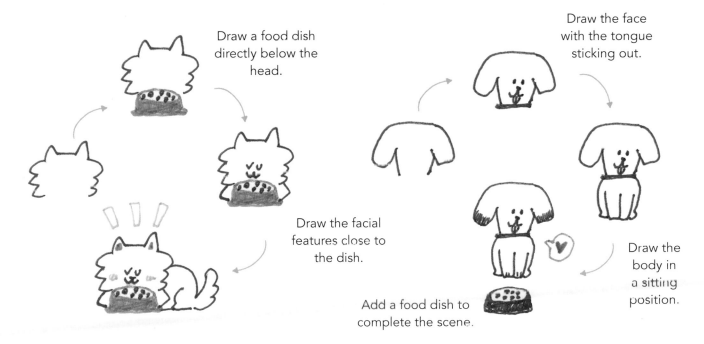

Draw a food dish directly below the head.

Draw the face with the tongue sticking out.

Draw the facial features close to the dish.

Add a food dish to complete the scene.

Draw the body in a sitting position.

RELAXING

When dogs are comfortable, they love to stretch out and relax...no matter where they may be!

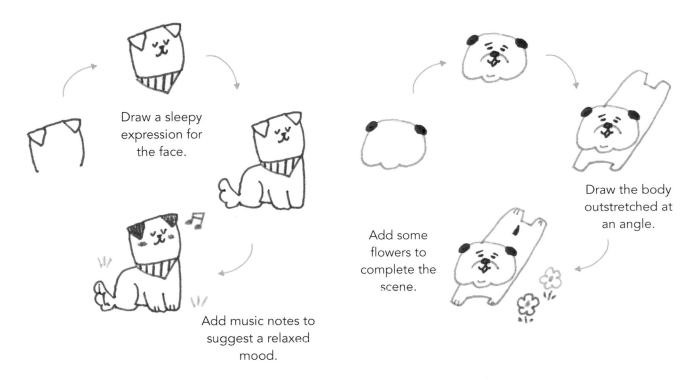

Draw a sleepy expression for the face.

Add music notes to suggest a relaxed mood.

Add some flowers to complete the scene.

Draw the body outstretched at an angle.

SNIFFING

Sniffing ranks among a dog's favorite pastimes. When drawing this pose, keep in mind the intensity of the dog's focus.

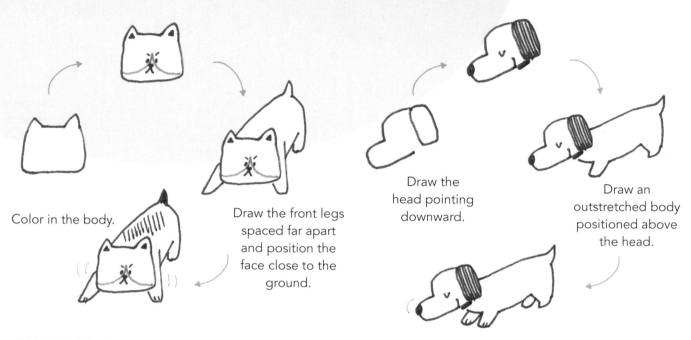

Color in the body.

Draw the front legs spaced far apart and position the face close to the ground.

Draw the head pointing downward.

Draw an outstretched body positioned above the head.

YAWNING

Dogs use the yawn as a calming signal. This means that they often yawn when they are stressed out or feel threatened, not just when they are tired.

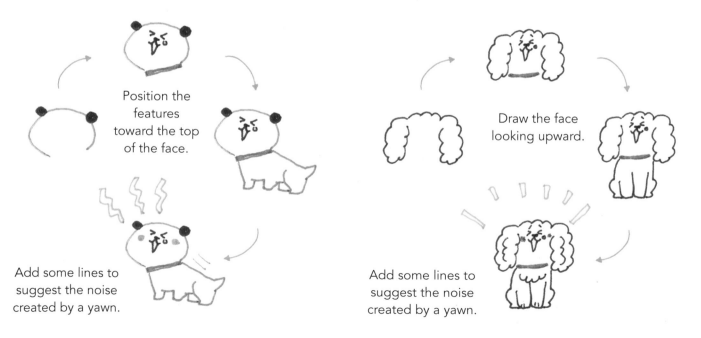

Position the features toward the top of the face.

Add some lines to suggest the noise created by a yawn.

Draw the face looking upward.

Add some lines to suggest the noise created by a yawn.

SLEEPING

These doggies are sound asleep. Sweet dreams!

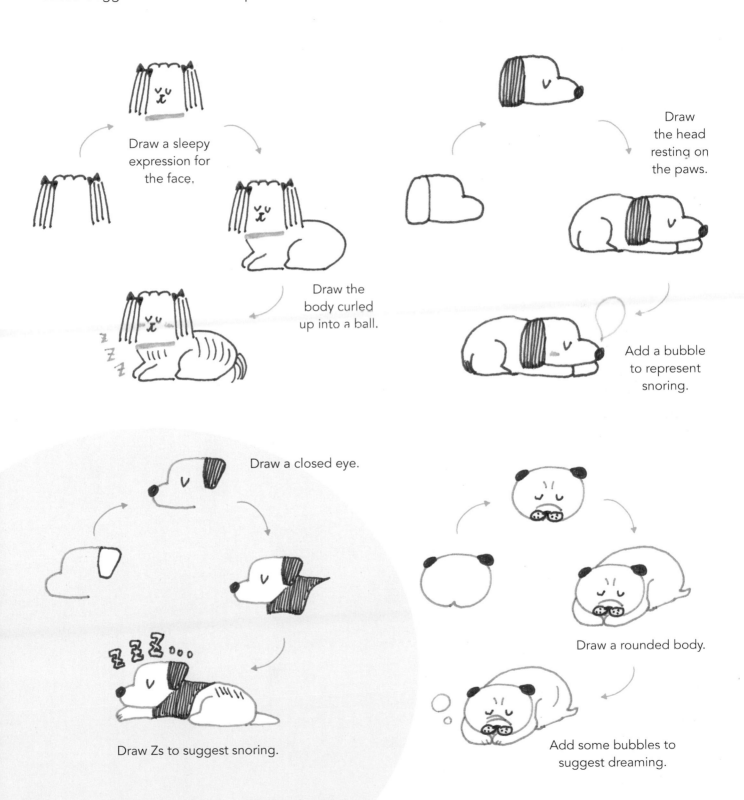

Draw a sleepy expression for the face.

Draw the body curled up into a ball.

Draw the head resting on the paws.

Add a bubble to represent snoring.

Draw a closed eye.

Draw Zs to suggest snoring.

Draw a rounded body.

Add some bubbles to suggest dreaming.

DOGS & THEIR STUFF

Now that you've had some practice drawing dogs, let's try drawing some dog-related items, such as toys and food. Next, combine what you've learned to create your own original illustrations of dogs out and about in the world.

Dog house

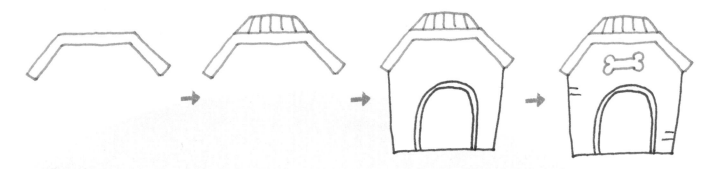

Draw the outline of the roof.

Draw a flat rooftop.

Draw the sides of the house and a large door.

Add some details to complete the dog house.

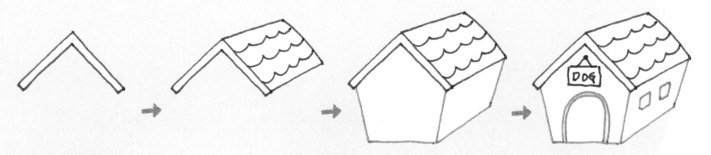

Draw a triangular roof.

Draw the side of the roof in perspective.

Draw the front and side walls.

Add a door, windows and a sign.

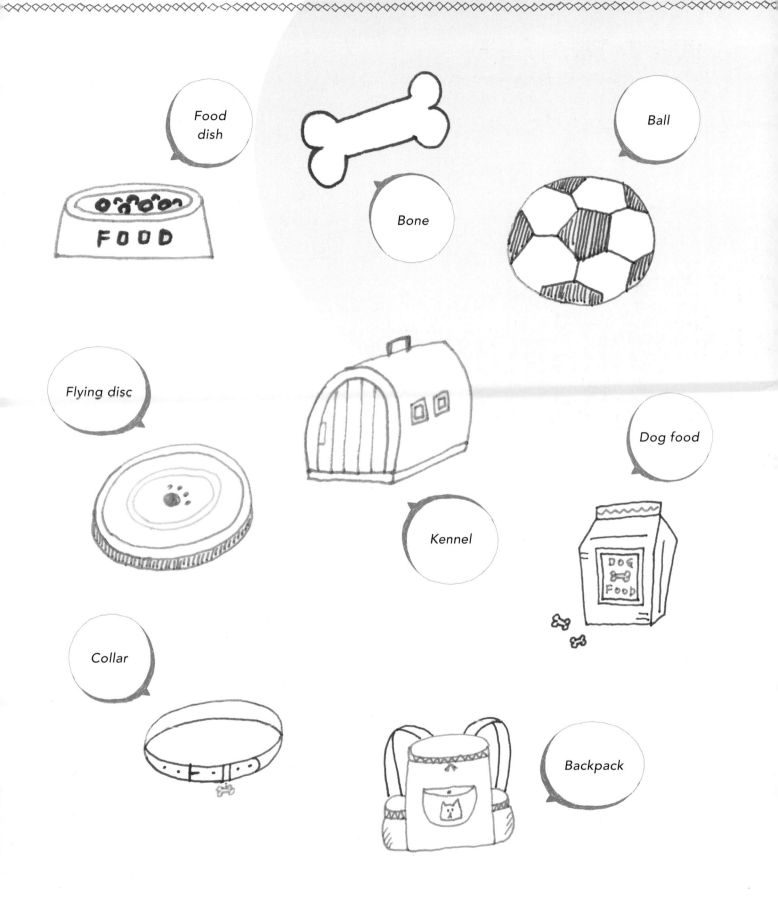

Dog...page 78
Dog house...page 88

There's No Place Like Home! 🐾

Dog...page 80
Dog house...page 88

Let's Hit the Road! 🐾

Woof!

Dog...page 78
Backpack...page 89

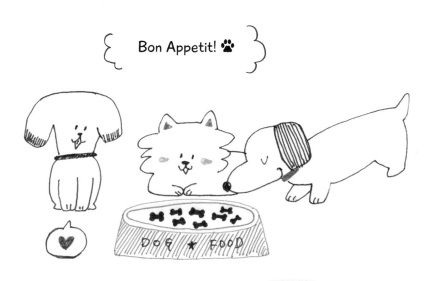

Bon Appetit! 🐾

Dogs...pages 85 and 86
Food dish...page 89

Play Time! 🐾

Dogs..page 82
Flying disc...page 89

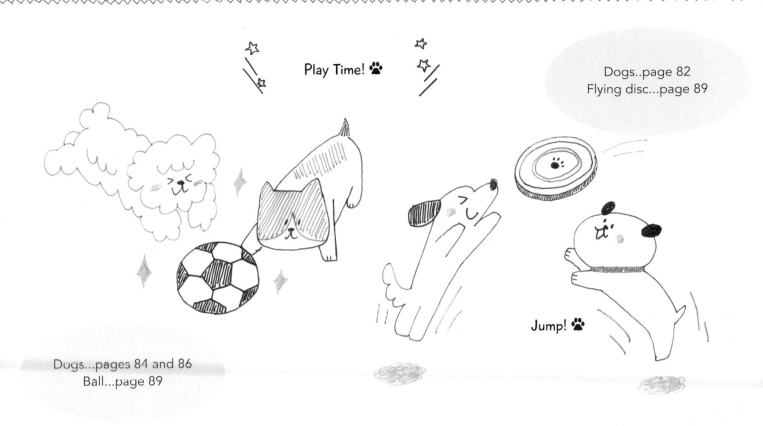

Dogs...pages 84 and 86
Ball...page 89

Jump! 🐾

This is the Life! 🐾

Dogs...pages
80 and 85

DOG BREEDS

We've compiled a collection of drawings representing 45 popular dog breeds. Are your favorites included?

SMALL DOGS

Small dogs make great companions because they love to cuddle. Many of these dogs are well-suited for living in apartments.

DACHSHUND

Known for short legs and long bodies.

Dachshunds have long snouts, so position the nose at a distance from the eyes.

Draw a long body with short legs.

CHIHUAHUA

Known for adorably large ears.

Draw large ears.

Draw the body small in proportion to the head.

PEKINGESE

Known for large, shining eyes.

Draw the tongue hanging out.

Draw small paws.

TOY POODLE

Resembles a stuffed animal.

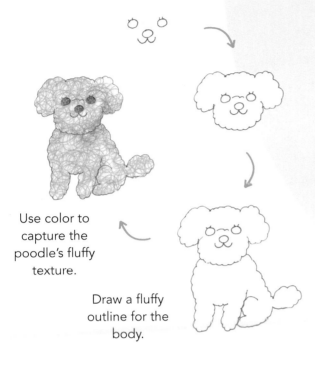

Use color to capture the poodle's fluffy texture.

Draw a fluffy outline for the body.

PUG

Known for its adorable face.

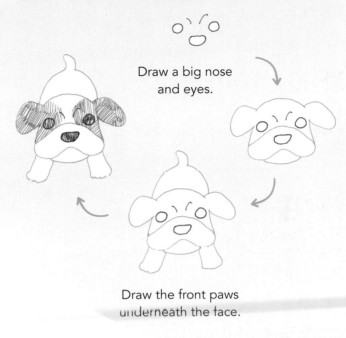

Draw a big nose and eyes.

Draw the front paws underneath the face.

SHIH TZU

Don't forget the long fur on the ears.

PAPILLON

Known for large ears and a pointy tail.

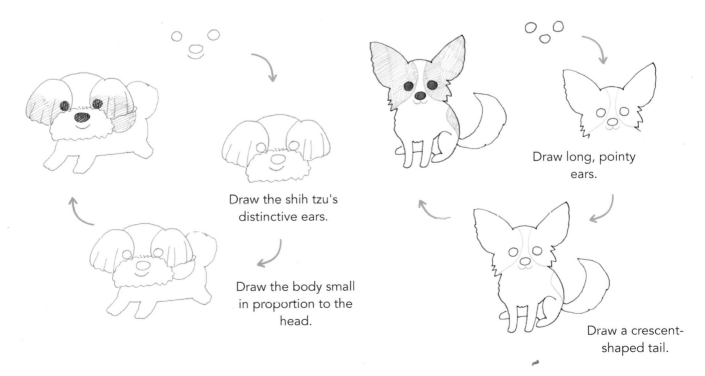

Draw the shih tzu's distinctive ears.

Draw the body small in proportion to the head.

Draw long, pointy ears.

Draw a crescent-shaped tail.

MAME SHIBA INU

A miniature version of the Shiba Inu.

Draw the eyes and nose at the center of the face.

Draw a curled tail.

YORKSHIRE TERRIER

Known for its long, silky hair.

Draw a long beard on both sides of the mouth.

Draw long hair that extends to the paws.

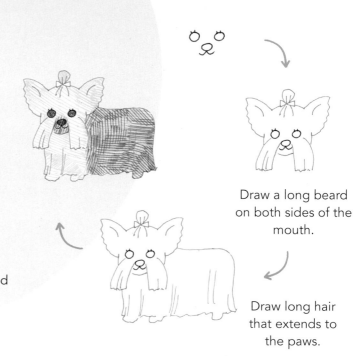

MINIATURE SCHNAUZER

Known for their distinguished beards.

The beard should cover half of the face.

Draw an outstretched body.

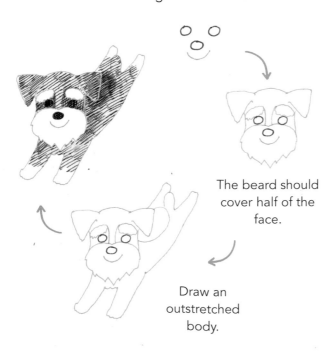

POMERANIAN

Known for their round, fluffy bodies.

Draw both a round face and body.

Draw a large, round tail.

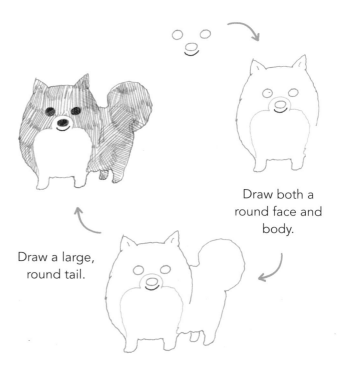

JACK RUSSELL TERRIER

These active dogs are often mischievous.

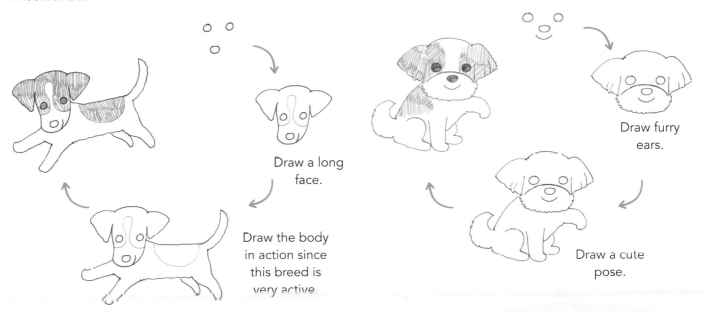

Draw a long face.

Draw the body in action since this breed is very active.

MALTESE

Known for being quiet and friendly.

Draw furry ears.

Draw a cute pose.

BEAGLE

Known for long, flat ears.

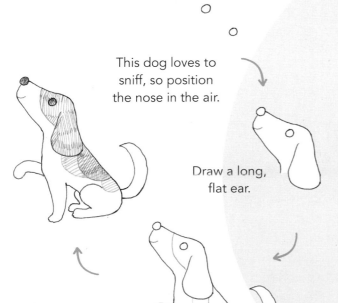

This dog loves to sniff, so position the nose in the air.

Draw a long, flat ear.

JAPANESE CHIN

Popular for its lovable face.

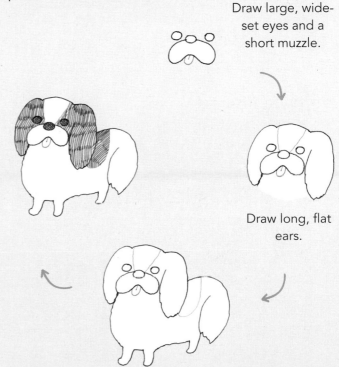

Draw large, wide-set eyes and a short muzzle.

Draw long, flat ears.

MEDIUM DOGS

These active dogs love to go for long walks and play games.

CORGI

Curious by nature.

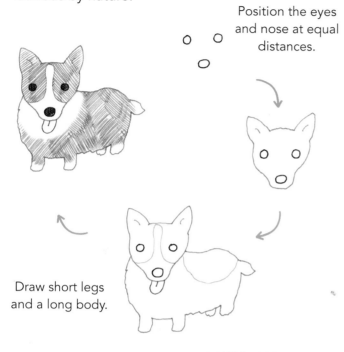

Position the eyes and nose at equal distances.

Draw short legs and a long body.

SHIBA INU

Looks like a fox.

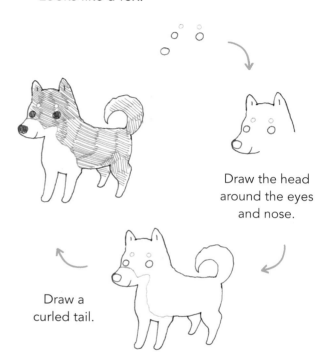

Draw the head around the eyes and nose.

Draw a curled tail.

BULL TERRIER

Known for its distinctive egg-shaped head.

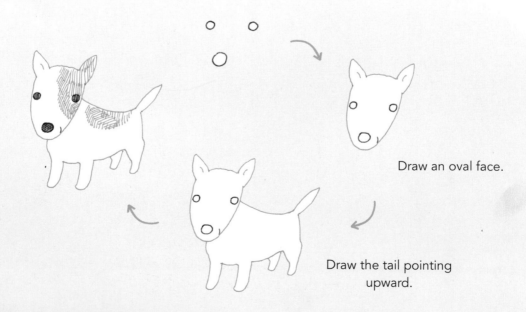

Draw an oval face.

Draw the tail pointing upward.

BORDER COLLIE

Known for obedience and intelligence.

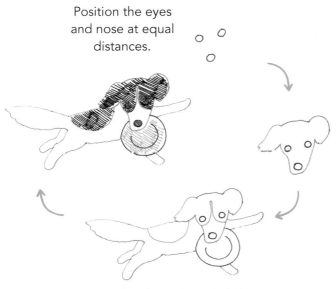

Position the eyes and nose at equal distances.

These dogs often compete in agility trials, so draw a toy in his mouth.

DALMATIAN

Famous for their spotted patterns.

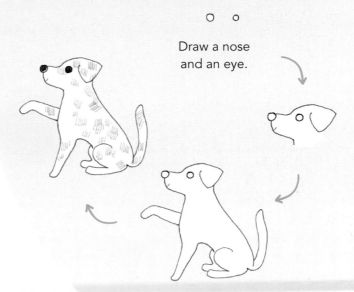

Draw a nose and an eye.

Draw the body executing the "paw" command.

HOKKAIDO

Known for their courage.

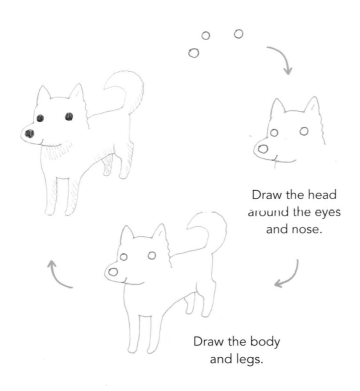

Draw the head around the eyes and nose.

Draw the body and legs.

SHETLAND SHEEPDOG

Ranks among the most intelligent dog breeds.

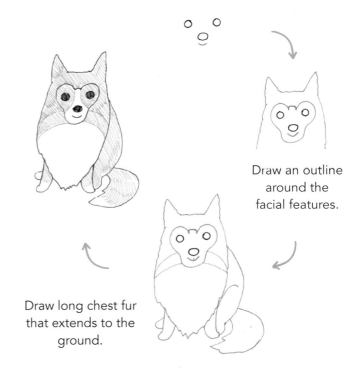

Draw an outline around the facial features.

Draw long chest fur that extends to the ground.

CHOW CHOW

Known for their characteristic scowling faces.

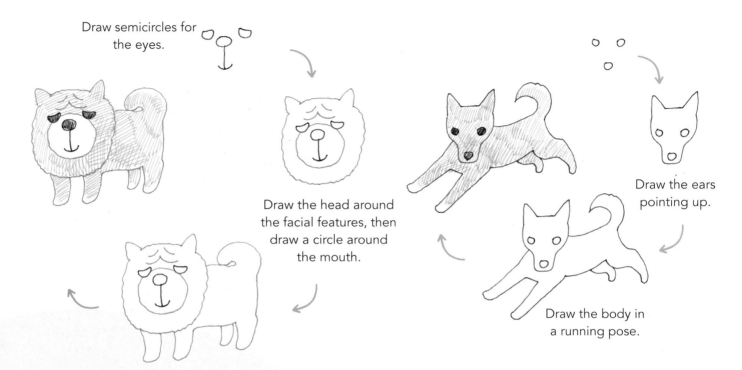

Draw semicircles for the eyes.

Draw the head around the facial features, then draw a circle around the mouth.

KAI

This rare dog breed is very loyal.

Draw the ears pointing up.

Draw the body in a running pose.

BULLDOG

Known for its adorably wrinkled face.

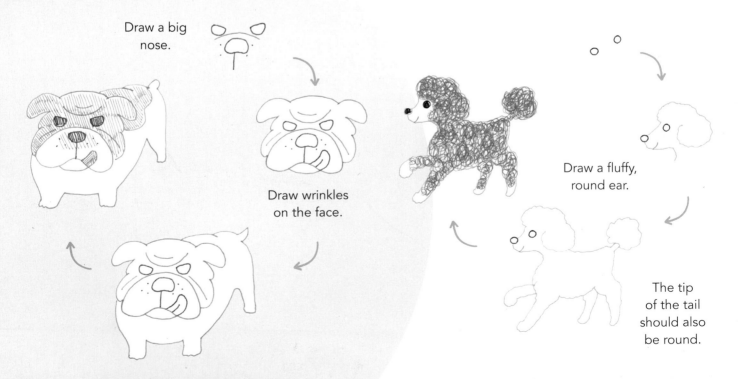

Draw a big nose.

Draw wrinkles on the face.

STANDARD POODLE

They often have fancy haircuts.

Draw a fluffy, round ear.

The tip of the tail should also be round.

COCKER SPANIEL

These elegant dogs are known for their beautiful fur.

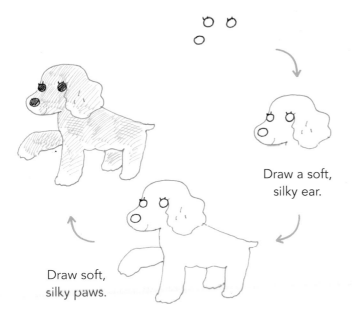

Draw a soft, silky ear.

Draw soft, silky paws.

BASSET HOUND

Known for their long ears.

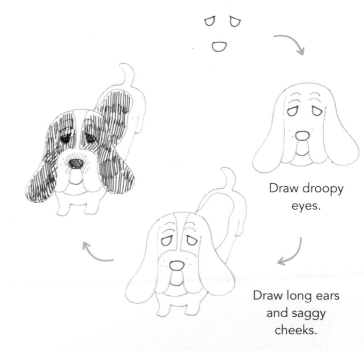

Draw droopy eyes.

Draw long ears and saggy cheeks.

SALUKI

This is a slim, graceful dog.

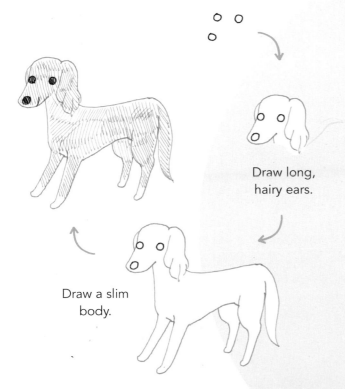

Draw long, hairy ears.

Draw a slim body.

PORTUGUESE WATER DOG

Has long, wavy hair.

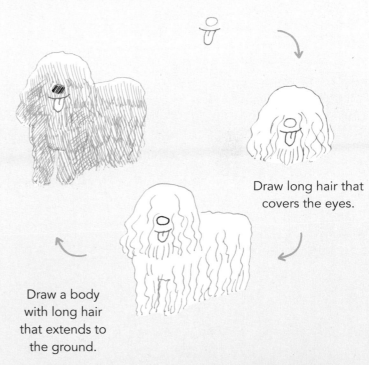

Draw long hair that covers the eyes.

Draw a body with long hair that extends to the ground.

LARGE DOGS

Quiet and intelligent, these large breeds make excellent working dogs. From herding sheep to rescuing people trapped in avalanches, these amazing animals can do just about anything!

LABRADOR RETRIEVER

Calm and smart, these dogs make excellent pets.

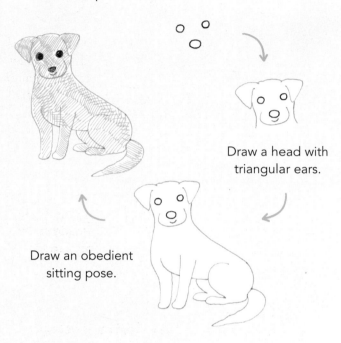

Draw a head with triangular ears.

Draw an obedient sitting pose.

GOLDEN RETRIEVER

This friendly, sweet breed is great with kids.

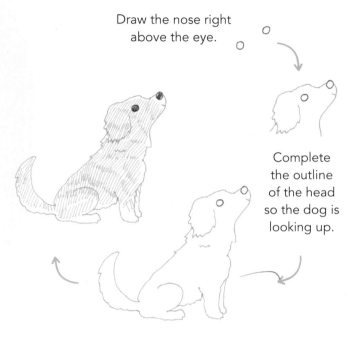

Draw the nose right above the eye.

Complete the outline of the head so the dog is looking up.

BERNESE MOUNTAIN DOG

These large dogs are strong and heavy.

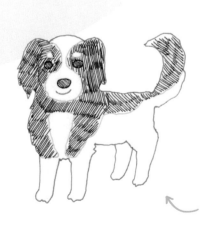

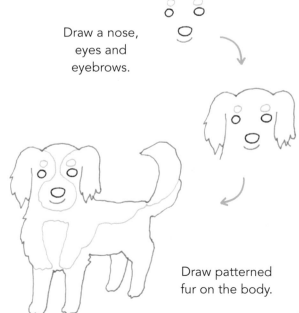

Draw a nose, eyes and eyebrows.

Draw patterned fur on the body.

GERMAN SHEPHERD

Often used for search-and-rescue.

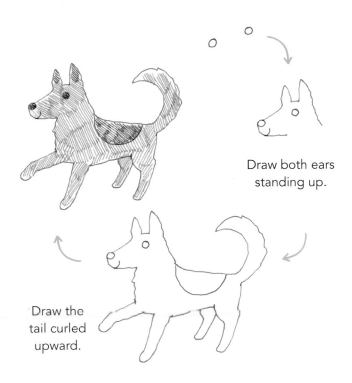

Draw both ears standing up.

Draw the tail curled upward.

SIBERIAN HUSKY

Used as sled dogs.

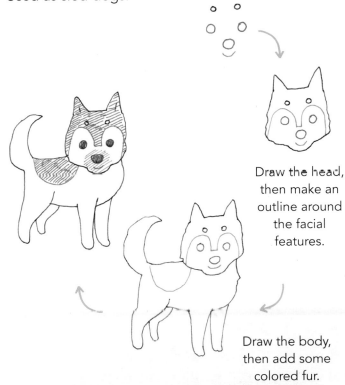

Draw the head, then make an outline around the facial features.

Draw the body, then add some colored fur.

DOBERMAN PINSCHER

They make excellent guard dogs.

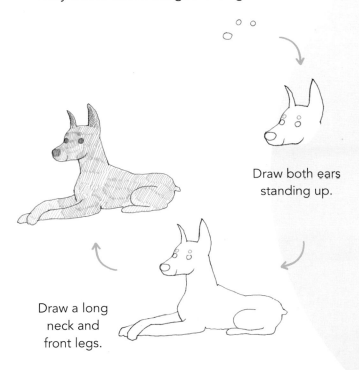

Draw both ears standing up.

Draw a long neck and front legs.

BOXER

Although powerful, this breed craves affection.

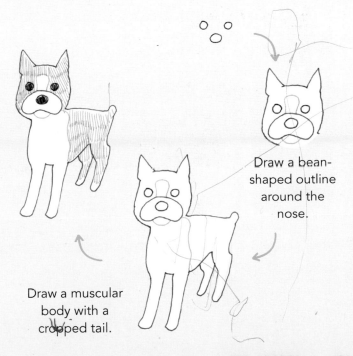

Draw a bean-shaped outline around the nose.

Draw a muscular body with a cropped tail.

BORZOI

Known as a fast runner.

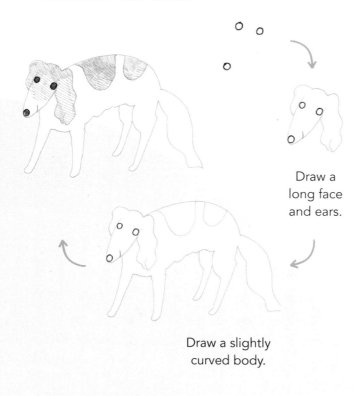

Draw a long face and ears.

Draw a slightly curved body.

SAINT BERNARD

Known for their enormous size.

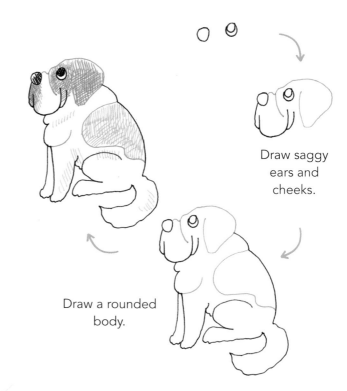

Draw saggy ears and cheeks.

Draw a rounded body.

IRISH SETTER

Known for their beautiful, silky coats.

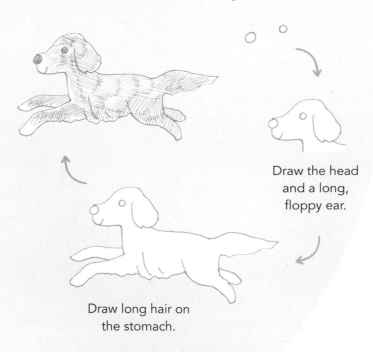

Draw the head and a long, floppy ear.

Draw long hair on the stomach.

AIREDALE TERRIER

Known as the "King of Terriers."

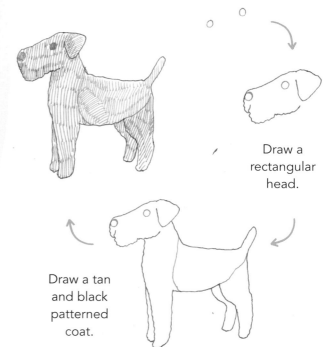

Draw a rectangular head.

Draw a tan and black patterned coat.

AKITA

These are large, loyal dogs.

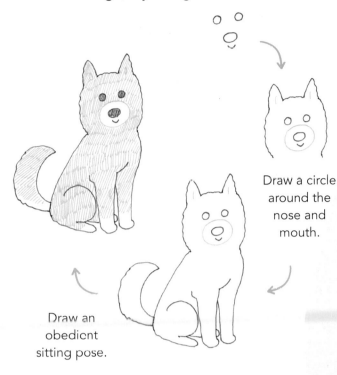

Draw a circle around the nose and mouth.

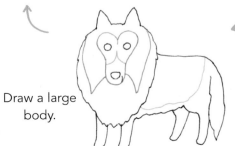

Draw an obedient sitting pose.

GREAT PYRENEES

They are excellent at guarding livestock.

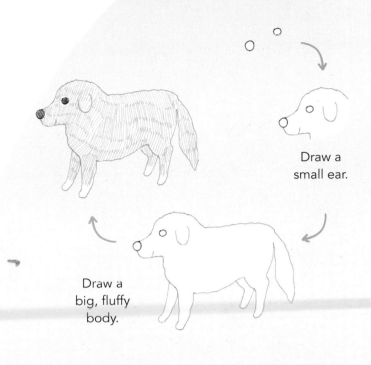

Draw a small ear.

Draw a big, fluffy body.

ROUGH COLLIE

Great at herding sheep.

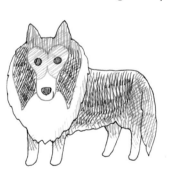

Draw fluffy chest hair.

Draw a large body.

AFGHAN HOUND

Known for its fine, silky coat.

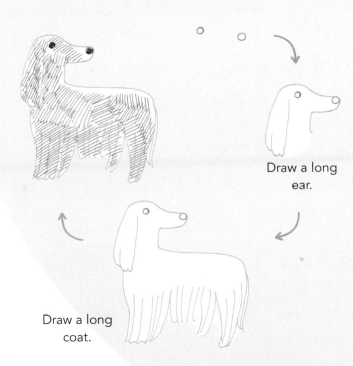

Draw a long ear.

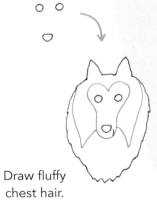

Draw a long coat.

DOODLE DOGS

BORDERS

Use these dog-themed borders to decorate cards and letters.

PAWPRINTS

BONES

DOGS PLAYING CHASE

DOG FACES

DOGS AND FLOWERS

IT'S A DOG'S LIFE

ALPHABET

We've created our own dog-inspired alphabet. Use this fun font to decorate cards, labels and handwritten notes.

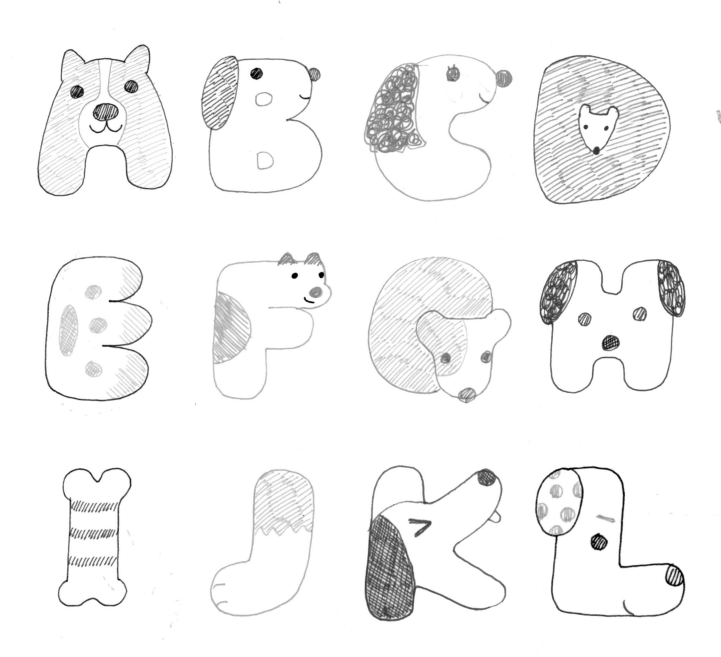

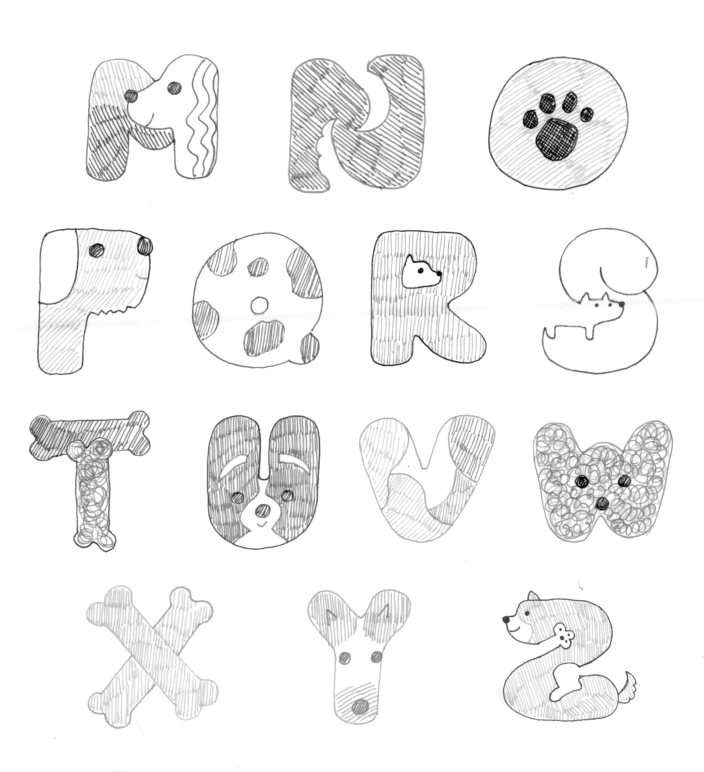

HOLIDAYS & SPECIAL EVENTS

These illustrations are designed to help you celebrate special occasions.

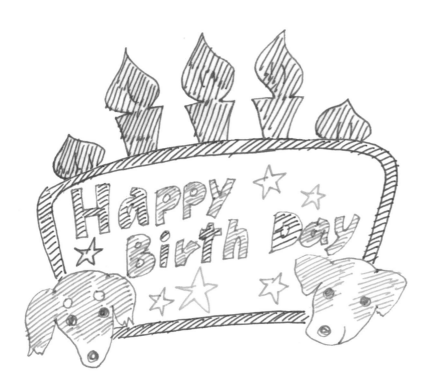

BIRTHDAYS

This design is just begging to be used for a birthday card.

CHRISTMAS

In addition to being used for a Christmas card, this motif can also be used for gift tags and wrapping paper.

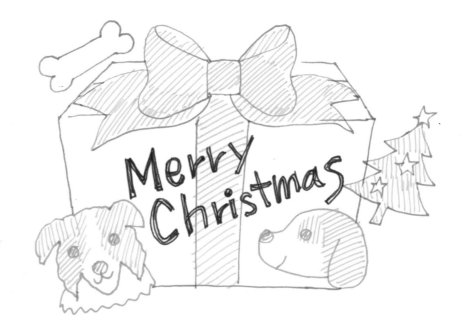

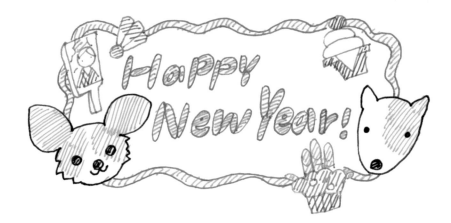

NEW YEAR'S DAY

Draw this design on a card or a traditional Japanese New Year's money bag.

HALLOWEEN

Use this Halloween illustration for party invitations and decorations.

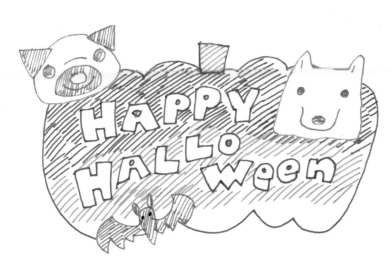

MOTHER'S DAY & FATHER'S DAY

This simple design is perfect any time you want to say "thank you" to someone you love.

GRANDPARENTS DAY

This design is perfect for Grandparents Day.

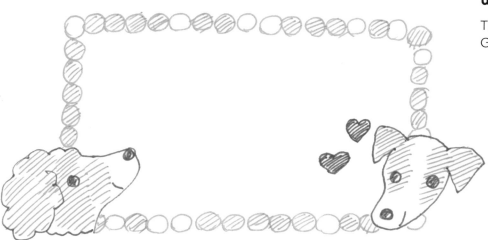

VALENTINE'S DAY

This dog-themed Valentine goes great with a box of chocolates (for humans only!).

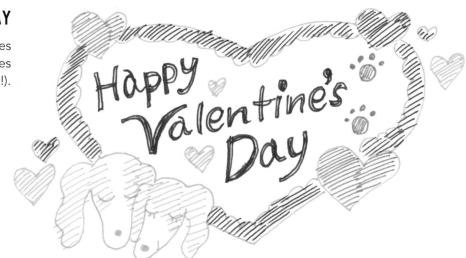

WEDDINGS

Create a special handmade wedding card to wish the couple wedded bliss.

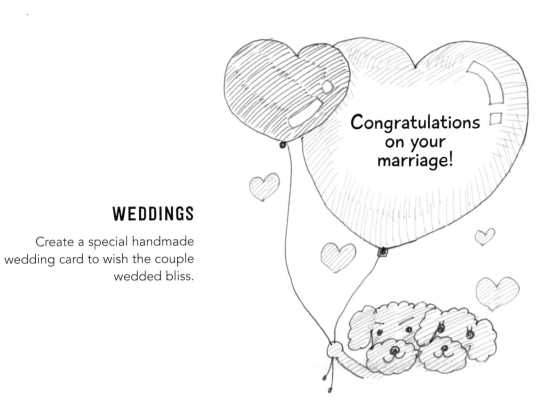

Congratulations on your marriage!

DESIGN YOUR OWN

Use this collection of fun illustrations to design your own greeting cards.

LOVE

DOG CHARACTERS

Dogs make excellent characters in stories and cartoons. You can create characters with distinct personalities by incorporating details such as clothing and accessories into your illustrations.

THE COUNTRY BOY

This mischievous Miniature Schnauzer loves action and adventure.

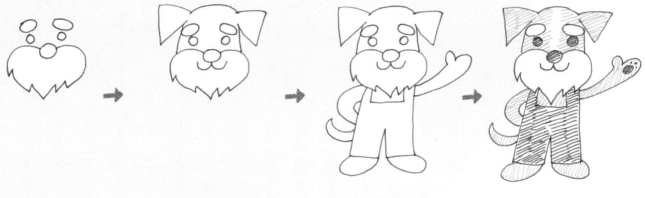

Draw the eyes and nose. Add a beard and bushy eyebrows.

Complete the outline of the head, including ears.

Draw some overalls.

Use bright colors to complete the illustration.

THE CITY GIRL

This sweet little Poodle loves fashion and is a world-class shopper.

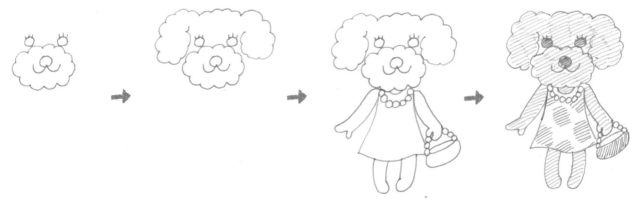

Draw the facial features, then draw a fluffy oval around the nose and mouth.

Complete the outline of the head, including ears.

Draw a dress, necklace and purse.

Add pattern to the dress and color in the rest of the illustration.

THE STUDENT

This well-dressed Shiba Inu gives off an over-achiever vibe.

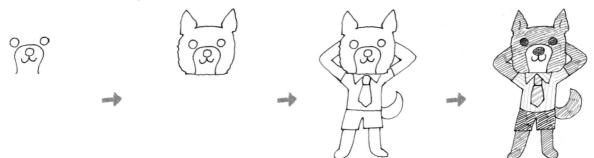

Draw the facial featuers, then add an outline around the mouth.

Complete the outline of the head, including ears.

Add some clothes, including a tie.

Add some stripes to the shirt and tie.

THE ARTIST

A beret and turtleneck lend an artistic impression to this distinguished-looking Irish Setter.

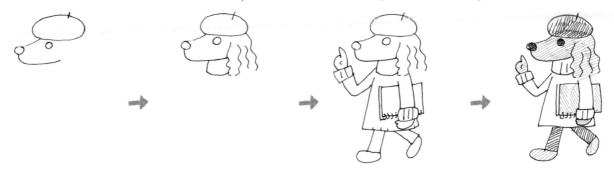

Draw the outline of the snout, then add a beret.

Add the neck and an ear with long, wavy hair.

Add the clothes and a sketchbook.

Add some color to complete the illustration.

THE ATHLETE

This beefy Bulldog spends a lot of time in the gym.

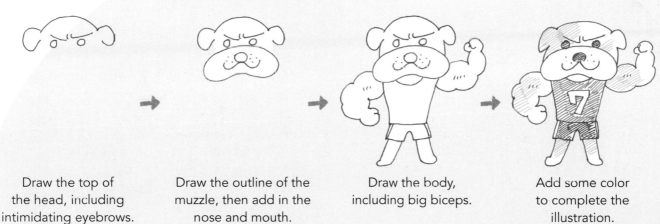

Draw the top of the head, including intimidating eyebrows.

Draw the outline of the muzzle, then add in the nose and mouth.

Draw the body, including big biceps.

Add some color to complete the illustration.

THE LADY

With her matching dress and bow, this fancy Maltese is the belle of the ball.

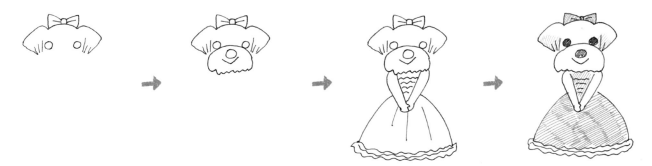

Draw the top of the head, then add a pretty bow.

Draw the outline of the muzzle, then add the nose and a smiling mouth.

Add a fancy dress.

Shade in her dress and bow using a feminine color scheme.

THE CHEF

This handsome Jack Russell Terrier is about to flip some burgers. As his apron says, he's one hot dog!

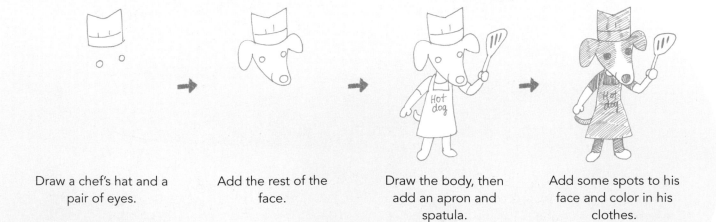

Draw a chef's hat and a pair of eyes.

Add the rest of the face.

Draw the body, then add an apron and spatula.

Add some spots to his face and color in his clothes.

THE MOTHER

This loving mother just returned from the market and is about to prepare dinner for her family.

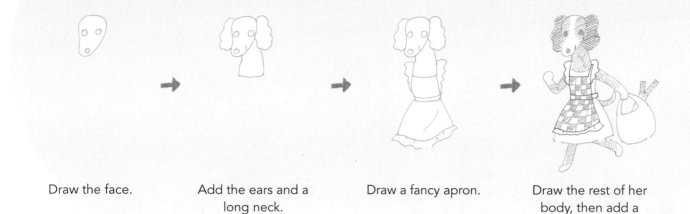

Draw the face.

Add the ears and a long neck.

Draw a fancy apron.

Draw the rest of her body, then add a grocery bag.

THE DOCTOR

You are in good hands (or should we say paws) with this trustworthy and compassionate doctor.

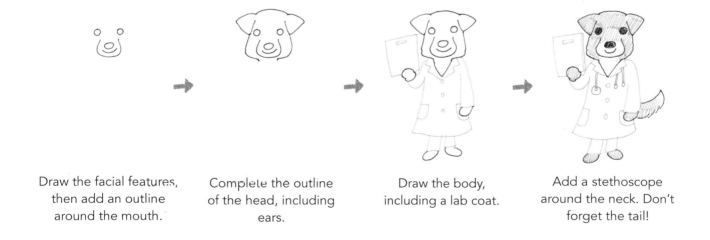

Draw the facial features, then add an outline around the mouth.

Complete the outline of the head, including ears.

Draw the body, including a lab coat.

Add a stethoscope around the neck. Don't forget the tail!

THE FLIGHT ATTENDANT

This Bull Terrier flight attendant is about to give a safety demonstration.

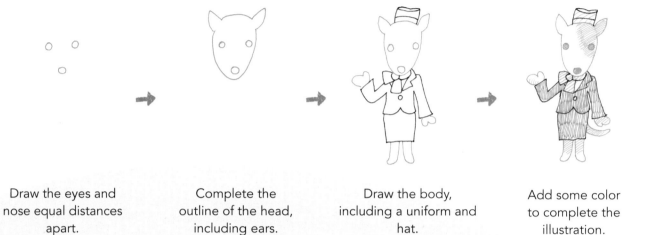

Draw the eyes and nose equal distances apart.

Complete the outline of the head, including ears.

Draw the body, including a uniform and hat.

Add some color to complete the illustration.

THE GEISHA

This Chihuahua is dressed in traditional Japanese clothing.

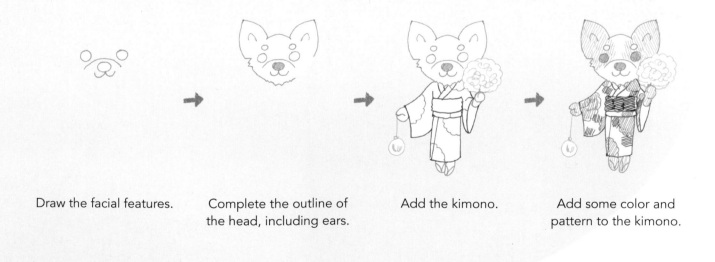

Draw the facial features.

Complete the outline of the head, including ears.

Add the kimono.

Add some color and pattern to the kimono.

THE TEENAGER

Teenage girls love to express their personal style, so add special details to her clothing.

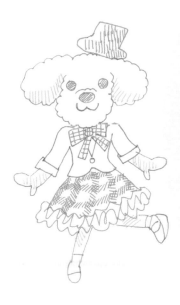

THE SAILOR

This Siberian Husky is ready to take to the high seas in his nautical-inspired ensemble.

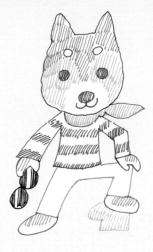

THE TRAVELLER

This Dalmation is headed off on a tropical vacation.

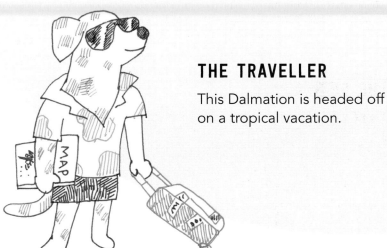

THE BAKER

This gentle giant is as soft and fluffy as the bread he bakes.

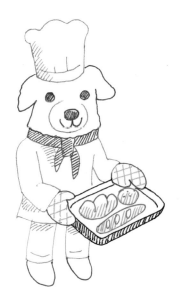

THE HULA GIRL

This Shih Tzu is perfoming a traditional Hawaiian dance.

THE SOCCER PLAYER

Use your favorite team as inspiration when drawing the uniform for this Airedale Terrier.

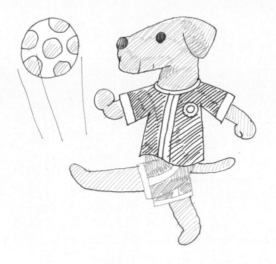

THE BRIDE & GROOM

Let's congratulate the lucky couple on tying the knot.

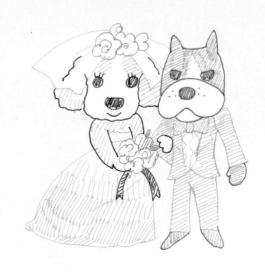

THE FISHMONGER

This tough guy slings fish down at the docks.

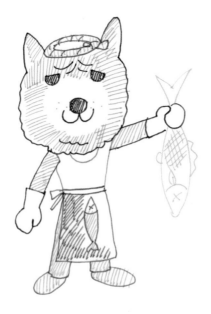

THE LADIES' MAN

This suave young man is about to sweep a lucky lady off her feet.

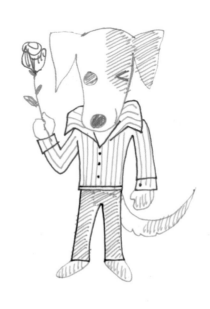

SENTIMENTS

Use these stamp-style illustrations for quick notes. Don't forget to add captions to ensure that your message gets delivered.

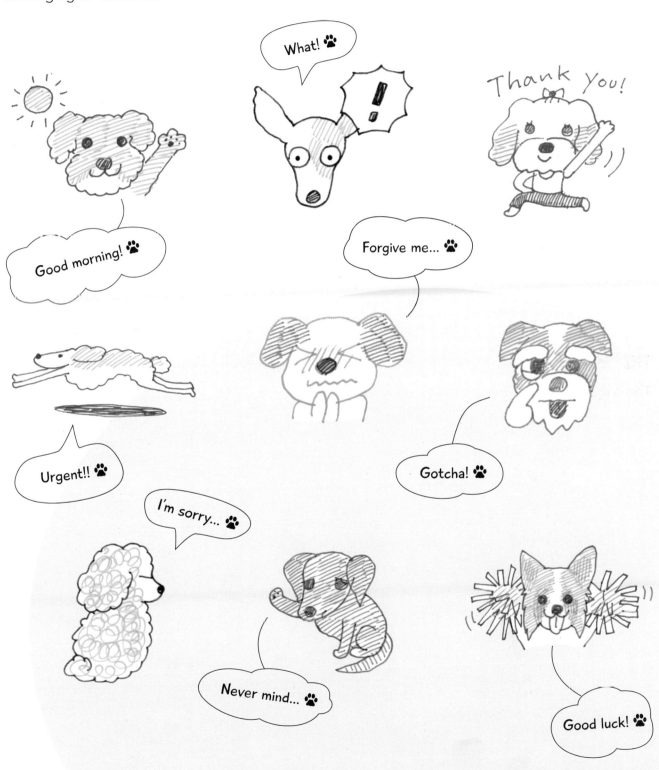

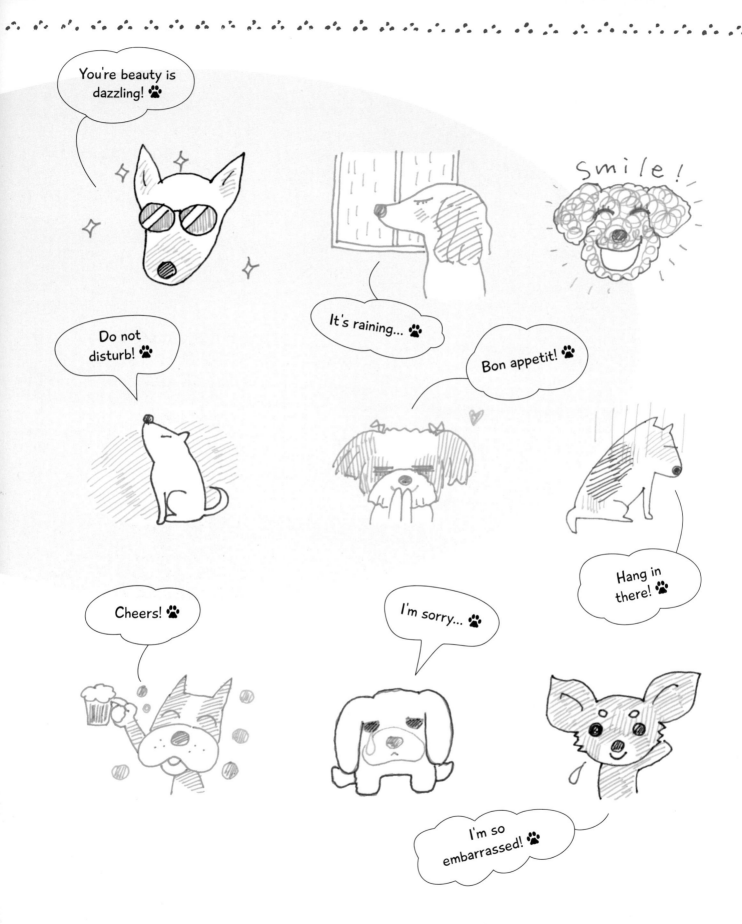

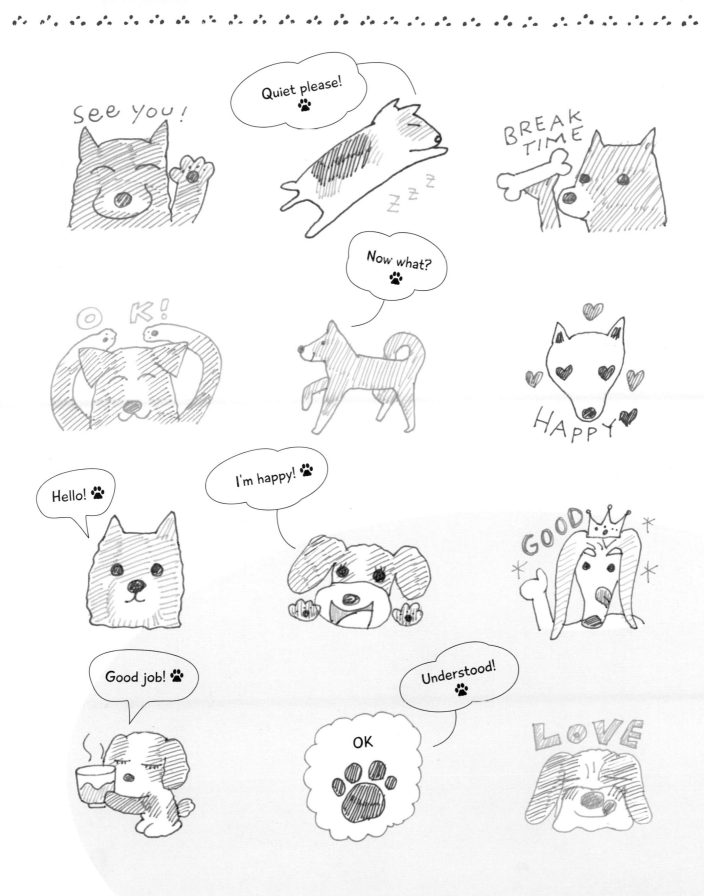

CALENDARS & APPOINTMENT BOOKS

Draw dog illustrations on your calendar to help you remember important events. You'll have so much fun, you might find yourself making plans just to have an excuse to add an illustration to your appointment book!

Illustrations featured on pages 89 and 90.

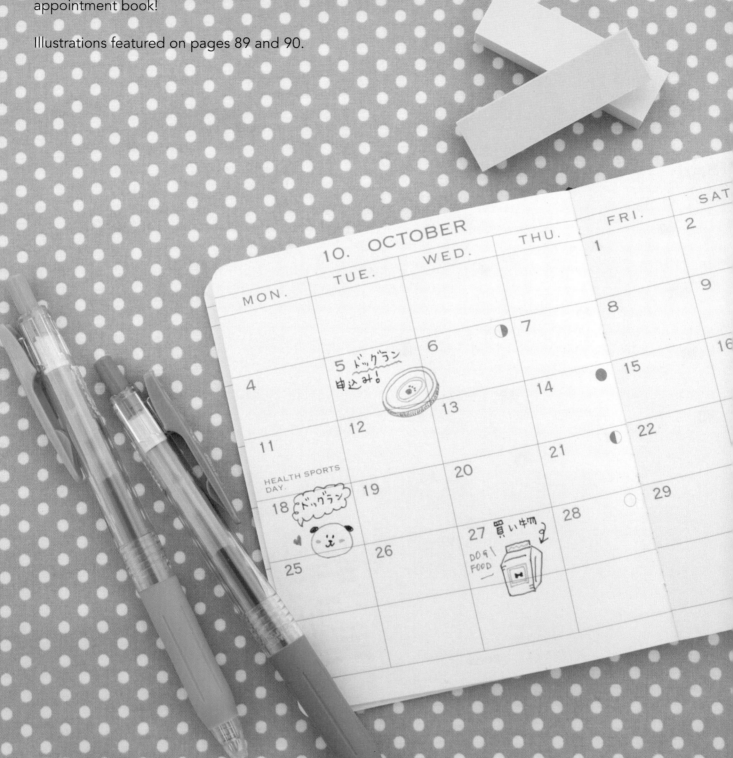

Illustrations featured on pages 76, 84 and 89.

These illustrations make it fun to look back through your appointment book and remember special events.

7月26日（日）晴れ🌤
リリと公園で遊んだ。
リリは チョウを見つけて
大はしゃぎ！！

=3

8/2　11:00〜

タローと
お出かけ

STATIONERY

Whether you are writing a quick memo to a co-worker or a heartfelt note to a friend, a few dog doodles are sure to bring a smile to their face.

Illustrations featured on page 121.

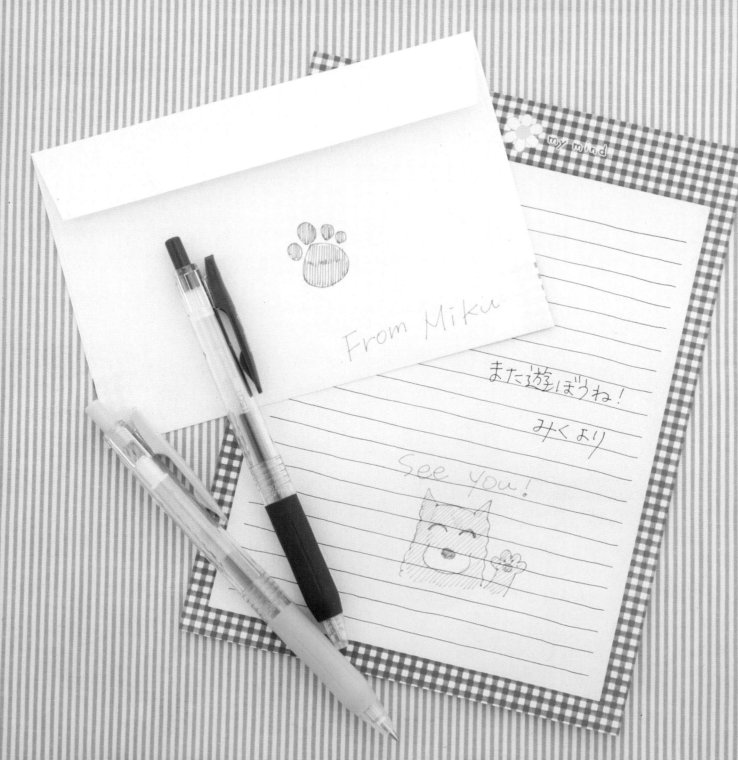

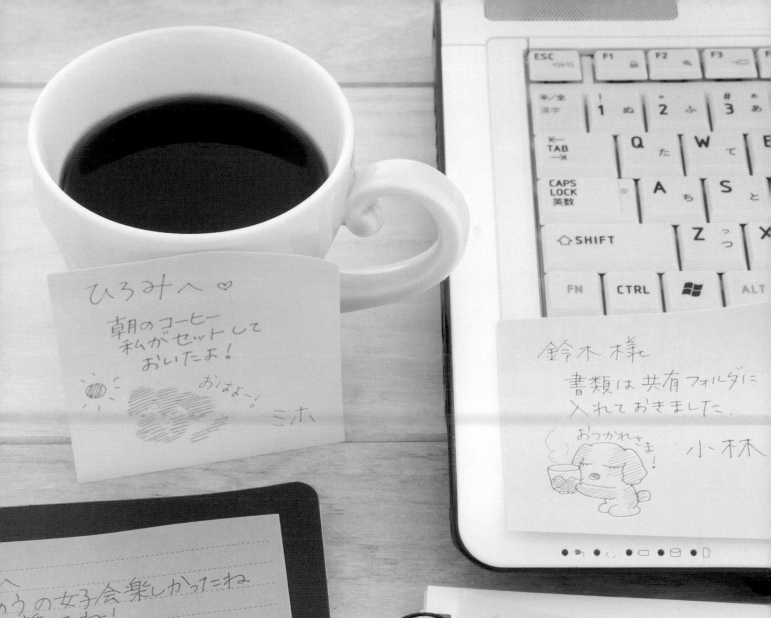
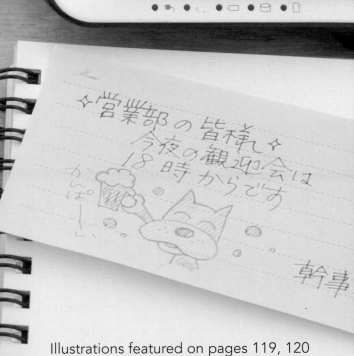

Illustrations featured on pages 119, 120 and 121.

GREETING CARDS & GIFT TAGS

These doggies will help you deliver warm wishes and special treats to your friends and family. Use these illustrations for gift tags, Valentine's and holiday cards.

Illustrations on pages 109, 110 and 119.

These adorable dogs will help you deliver special messages to your friends and family.

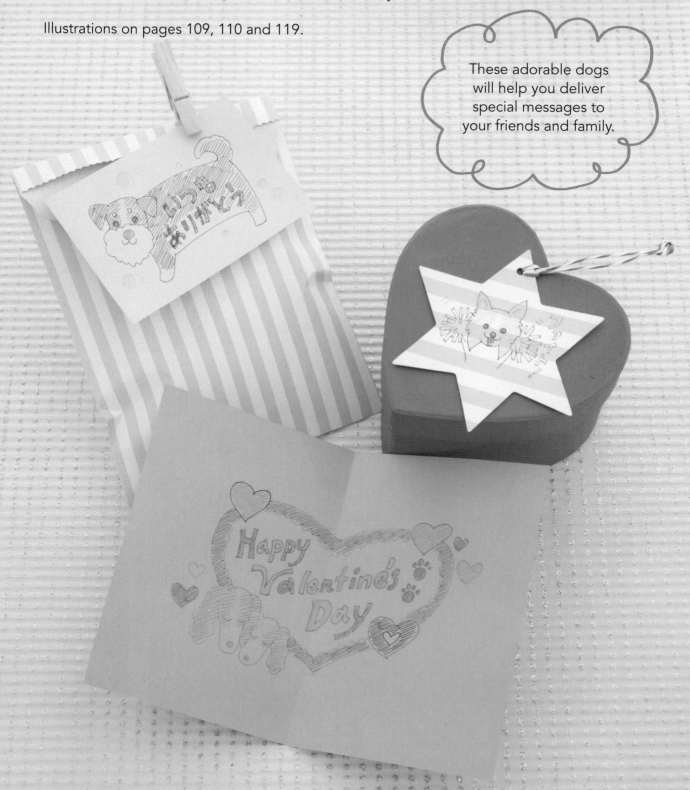

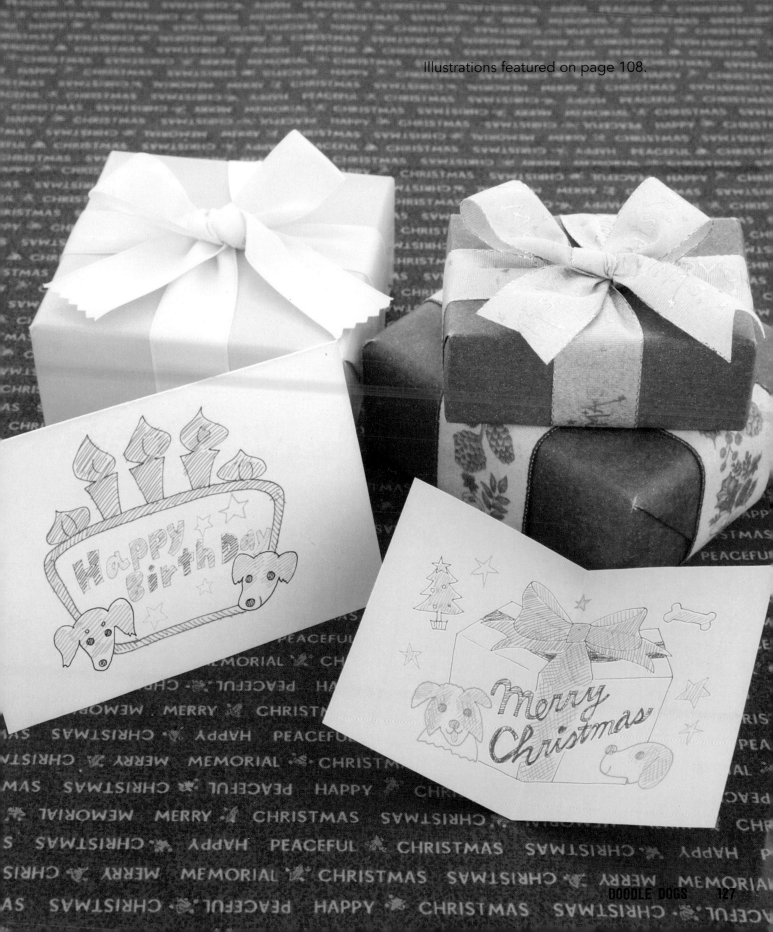

Illustrations featured on page 108.

ABOUT THE ARTISTS

Erina Kusaka

- Illustrator and painter who enjoys working with acrylics.
- Has a tuxedo cat named Kotaro.

Noriko Koshitaka

- Illustrates for a variety of books and magazines.
- Has two tabby cats: one orange and one brown.

BOUS original work (yuki)

- Illustrator and rubber stamp artist whose work has been featured in a variety of advertisements.
- Currently renovating an old house which she hopes to transform into her dream studio.

Rieko Wakayama

- Works at a printing company and enjoys illustrating in her spare time.
- Has a cat named Mirin who likes to complain and run around the house at crazy speeds.

MIWA ★

- Known for cute, pop-culture inspired illustrations that are admired by kids and adults alike.
- Loves to draw happy cats!

Harumi Matsui

- Award-winning freelance illustrator whose work has been used in a variety of books, magazines and advertisements.
- Studied at the Nagoya Zokei University of Art & Design.

Fumika Hayashi

- Enjoys drawing simple, easy illustrations featuring animals and humans.

Ayumi Takamura

- Enjoys drawing characters for books, websites and advertisements.
- Resides in Tokyo.
- Her favorite food is curry.